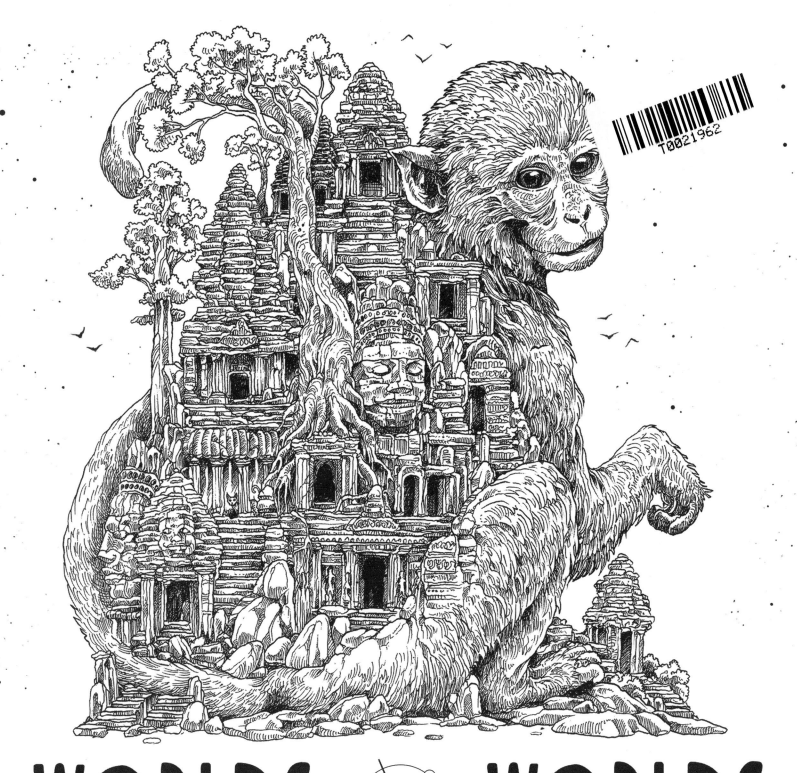

WORLDS WITHIN WORLDS

A PLUME BOOK

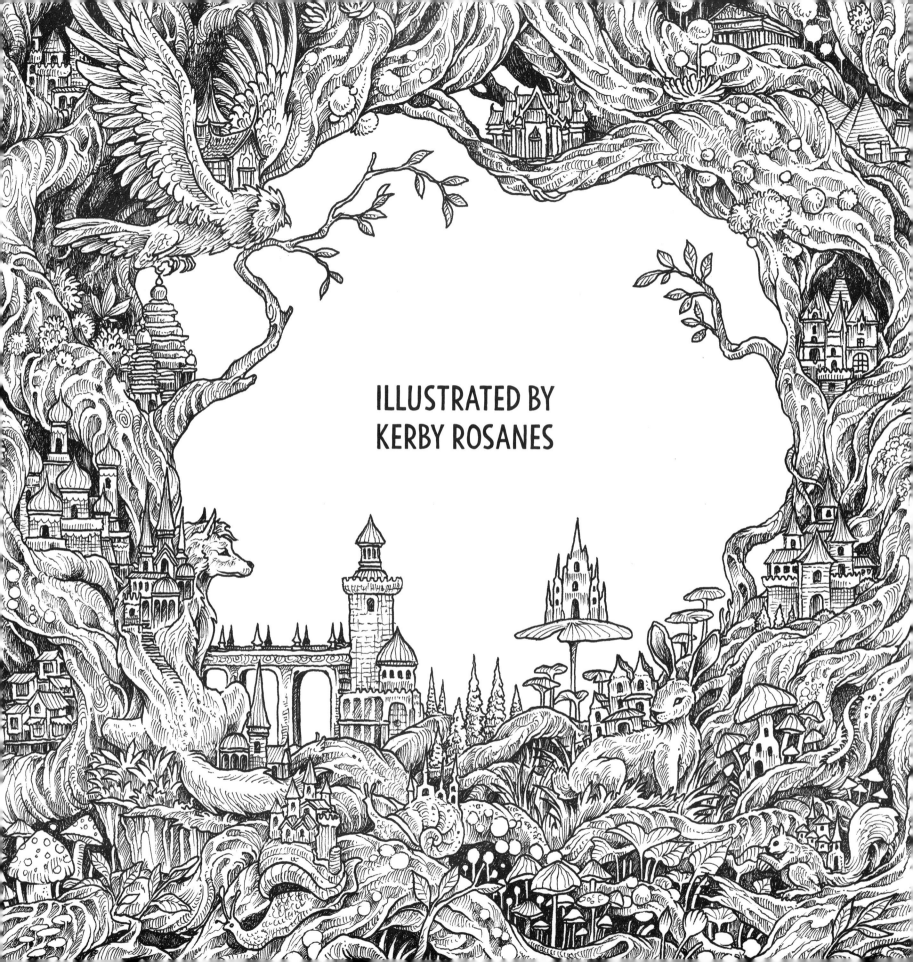

ILLUSTRATED BY
KERBY ROSANES

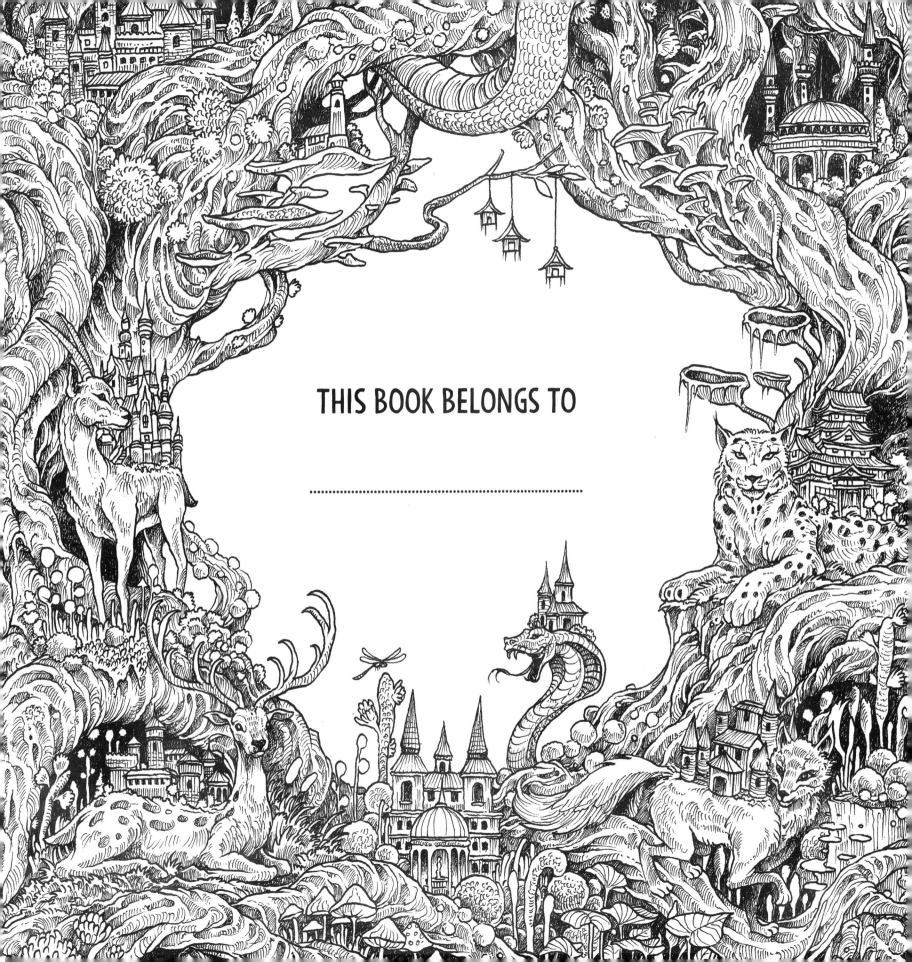

THIS BOOK BELONGS TO

..

EDITED BY HELEN BROWN
DESIGNED BY DERRIAN BRADDER
COVER DESIGN BY JOHN BIGWOOD

WITH THANKS TO HARRY THORNTON
FOR BEING A GREAT TALENT SCOUT

PLUME
An imprint of Penguin Random House LLC
penguinrandomhouse.com

First published in Great Britain in 2019 by
LOM ART, an imprint of Michael O'Mara Books Limited,
9 Lion Yard, Tremadoc Road, London SW4 7NQ

 mombooks.com/lom

Michael O'Mara Books

OMaraBooks

ISBN 9780593086230

Printed in the United States of America
9th Printing

DISCOVER NEW REALMS IN THIS COLORING ADVENTURE!

Step into my high-definition, super-detailed world, where enchanting realms and entire universes are transported to strange and wonderful new habitats.

Each intricate illustration has been crafted with fineliner pens and can be colored in any way you like.

Look out for the magic key in every scene, which is hidden beside a clue that will unlock the next world. You can find all the answers at the back of the book.

Kerby Rosanes

KERBY

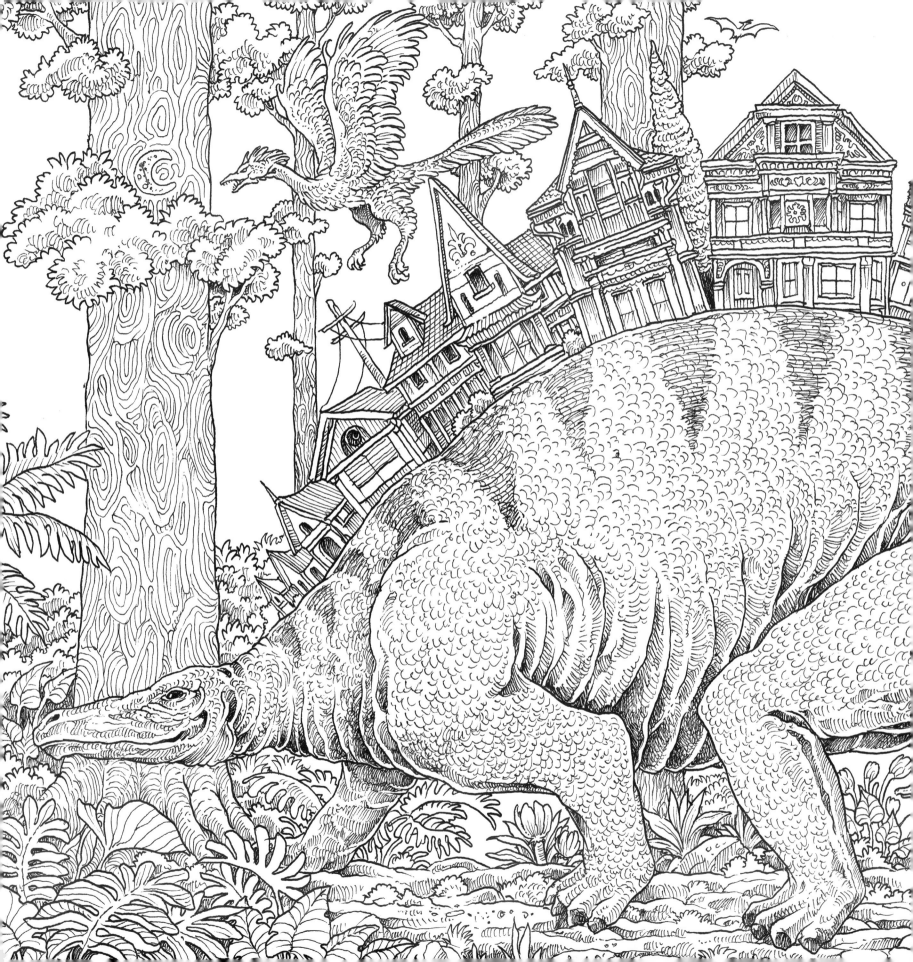

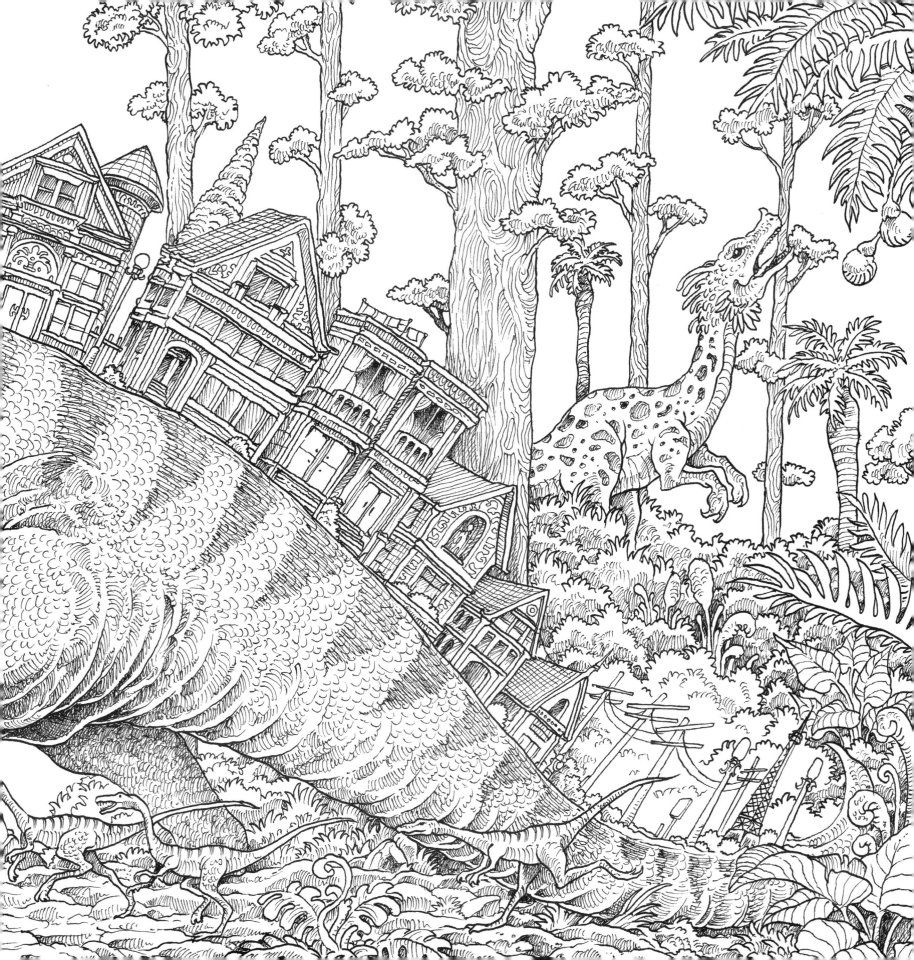

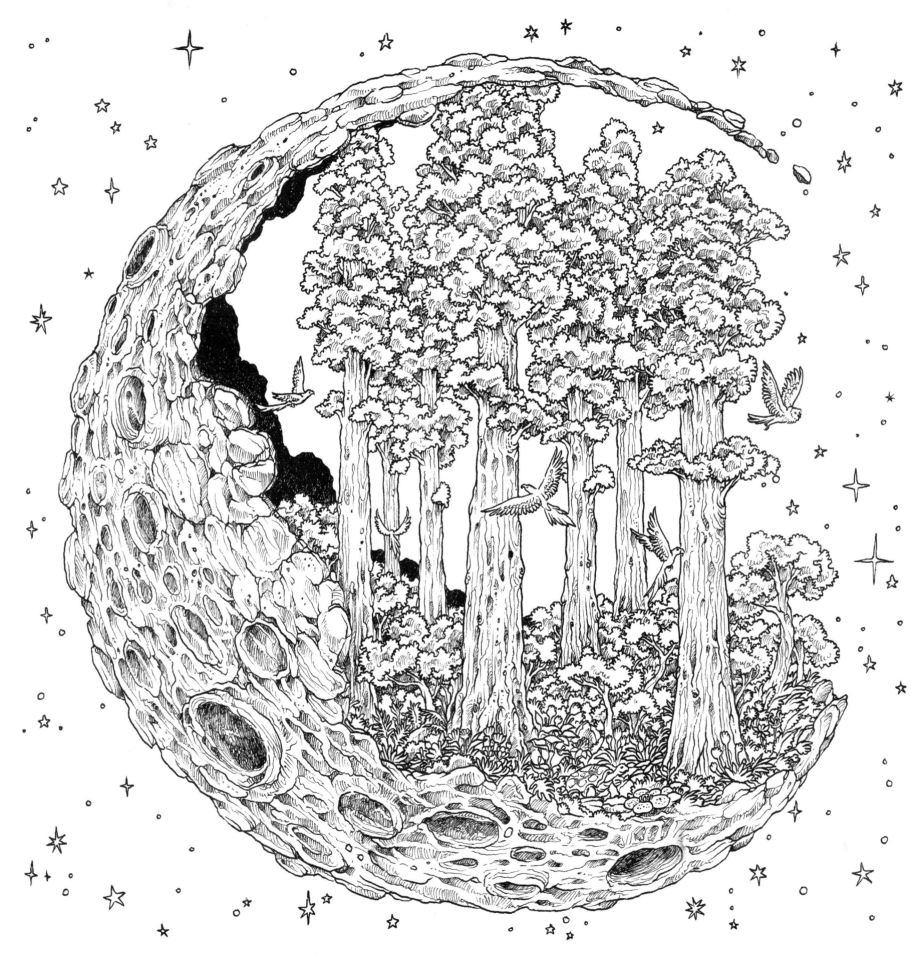

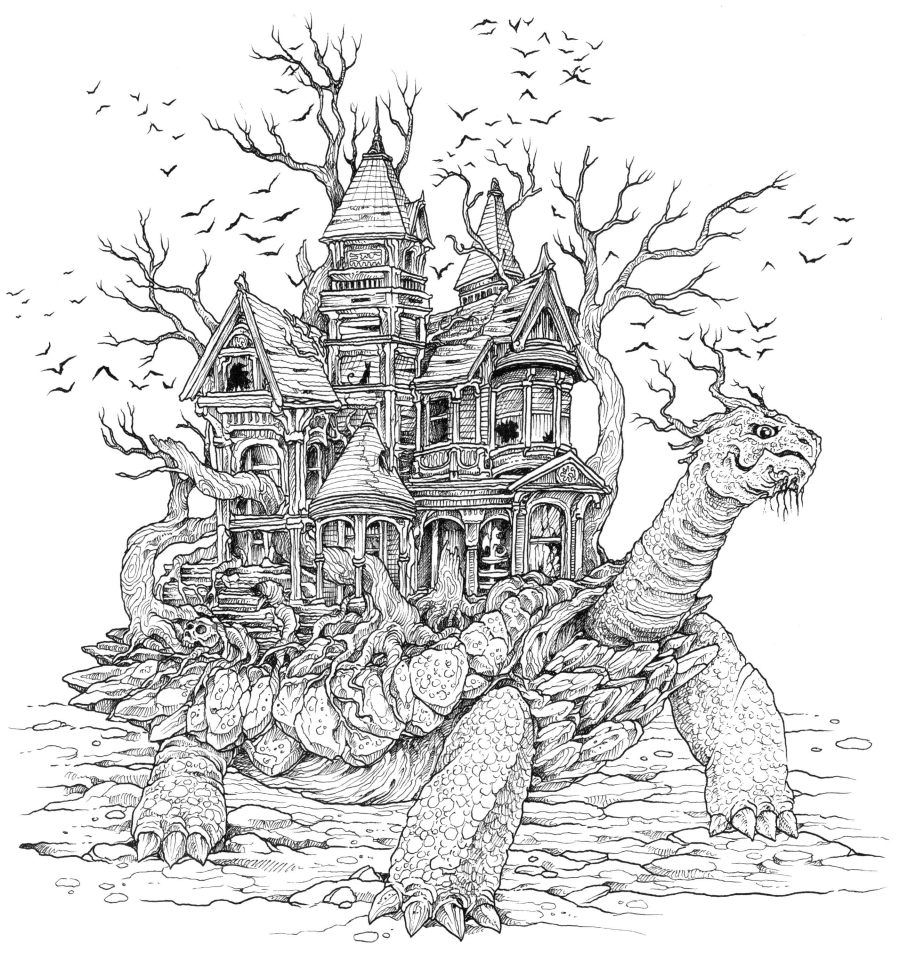

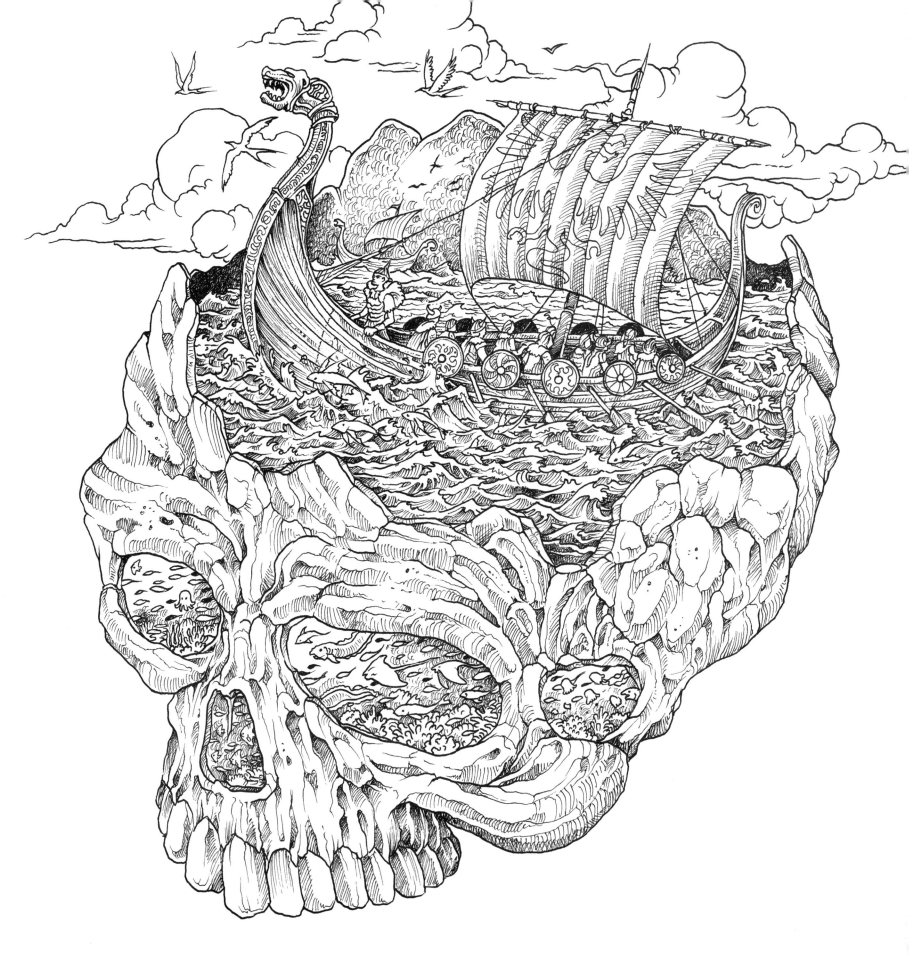

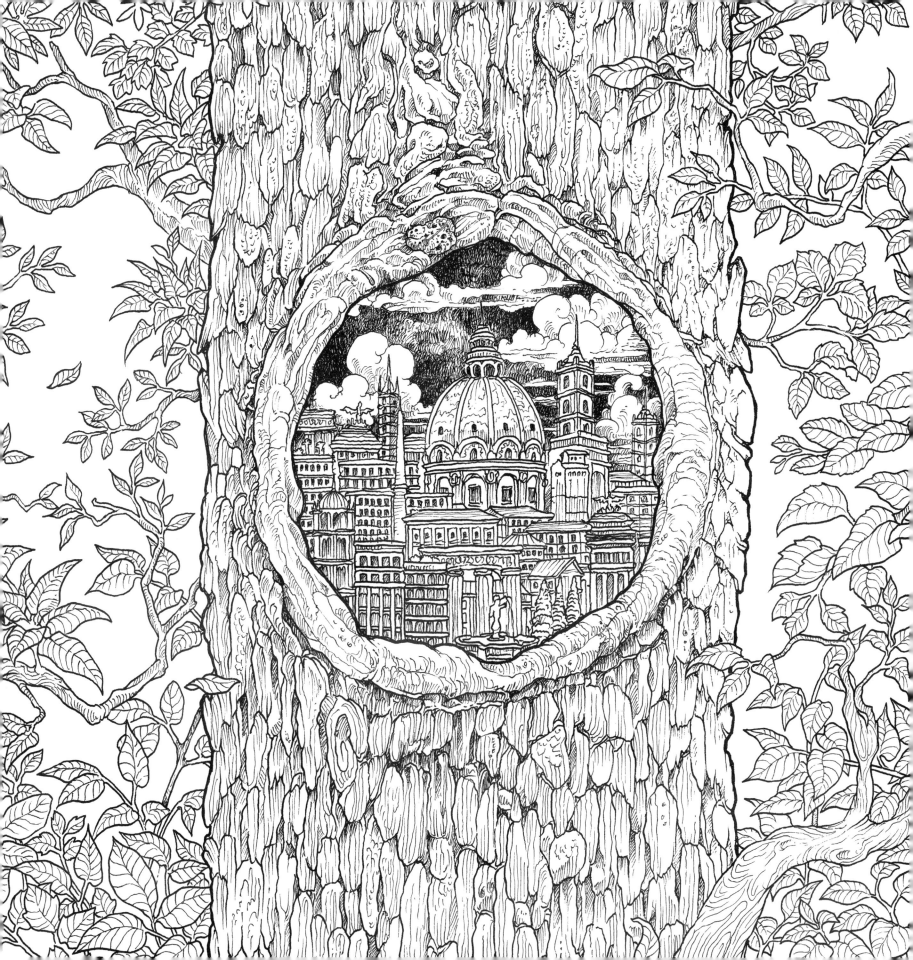

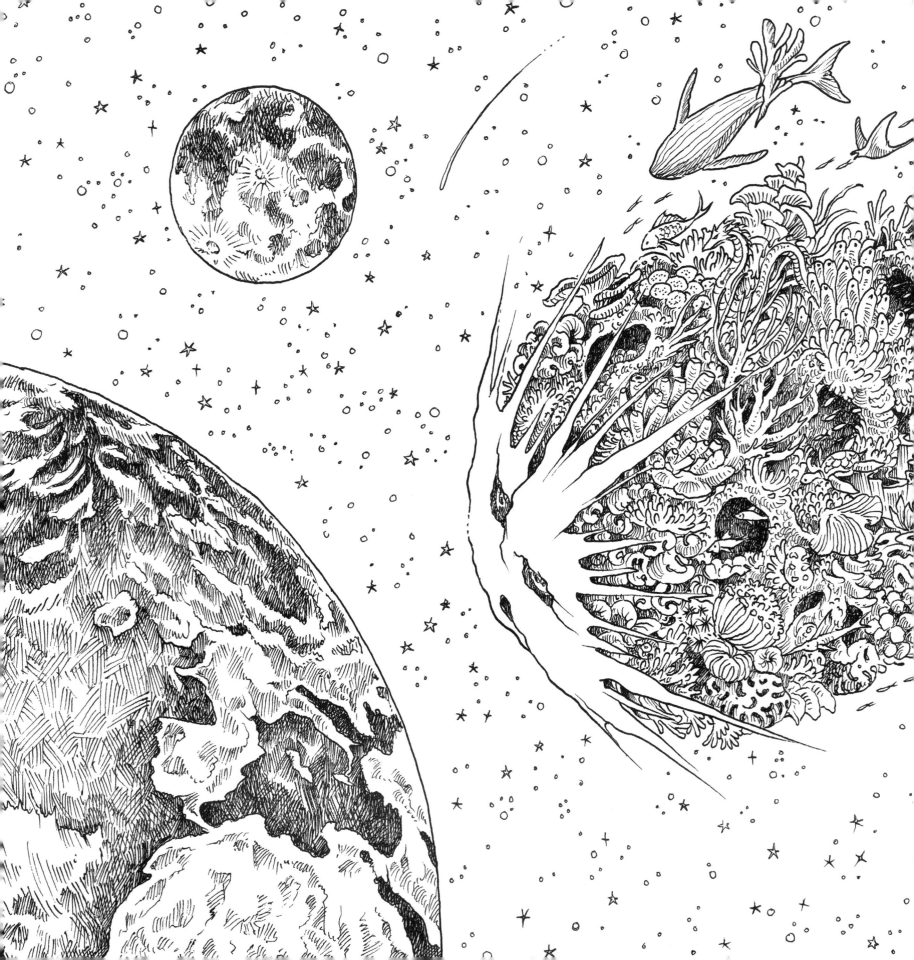

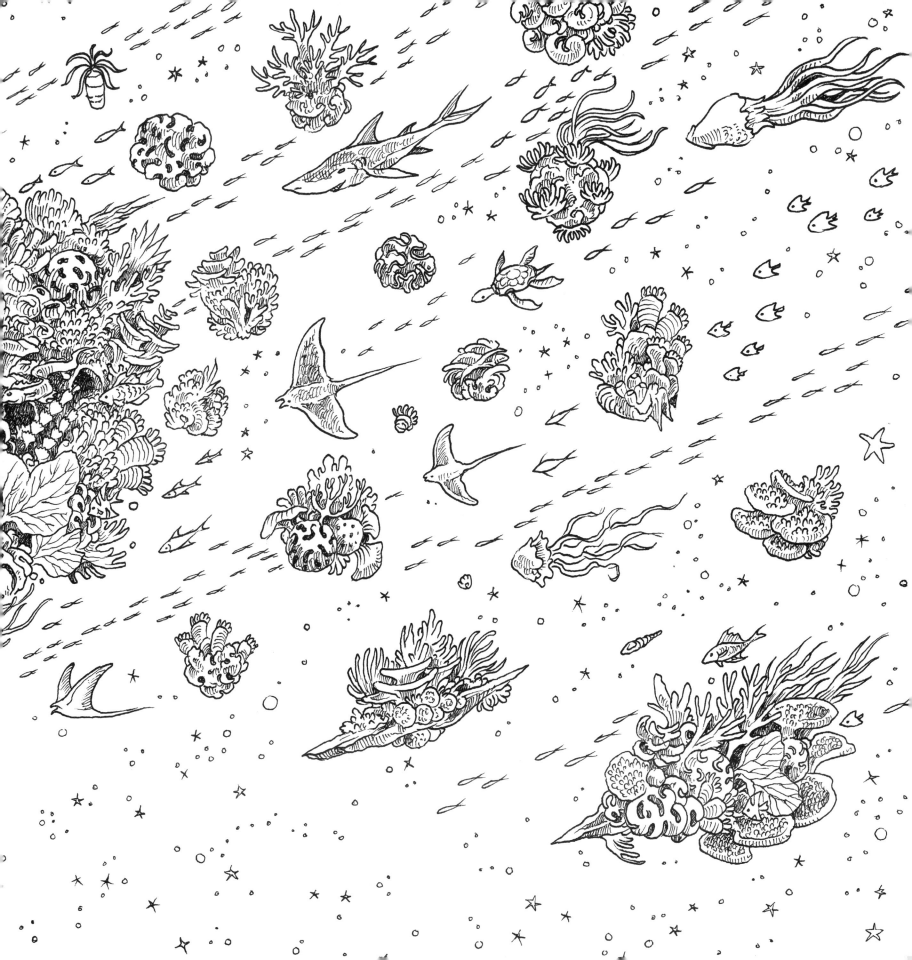

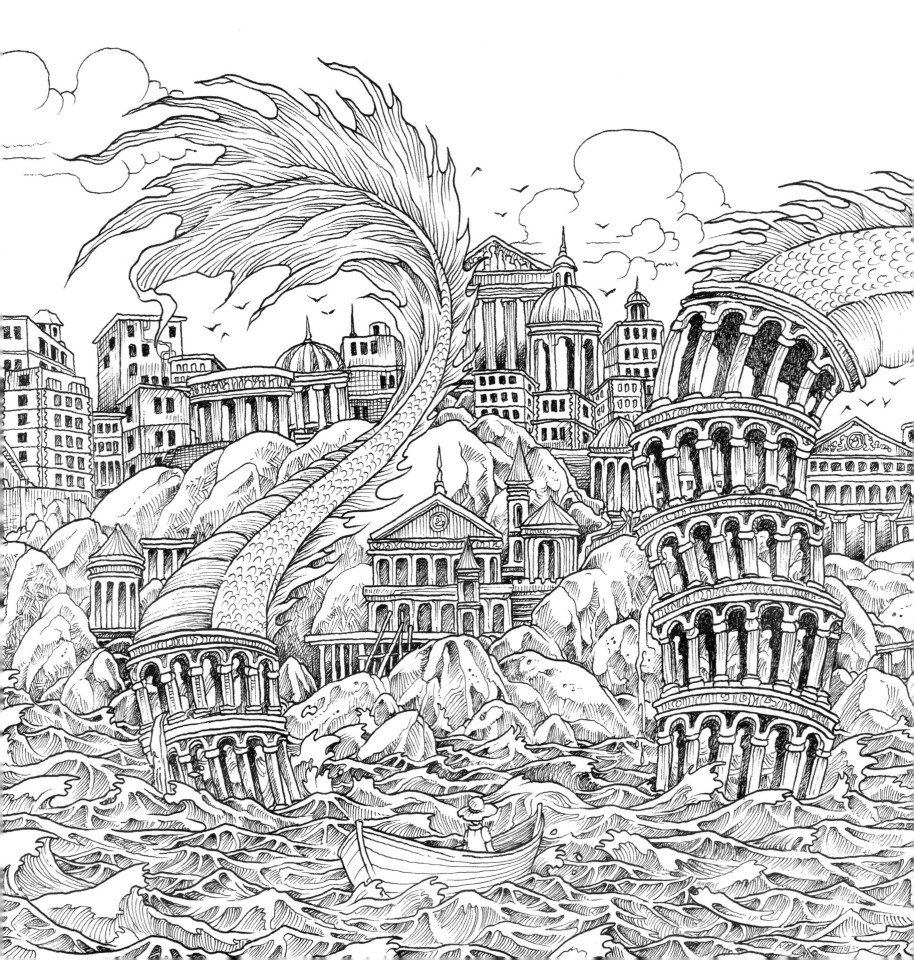

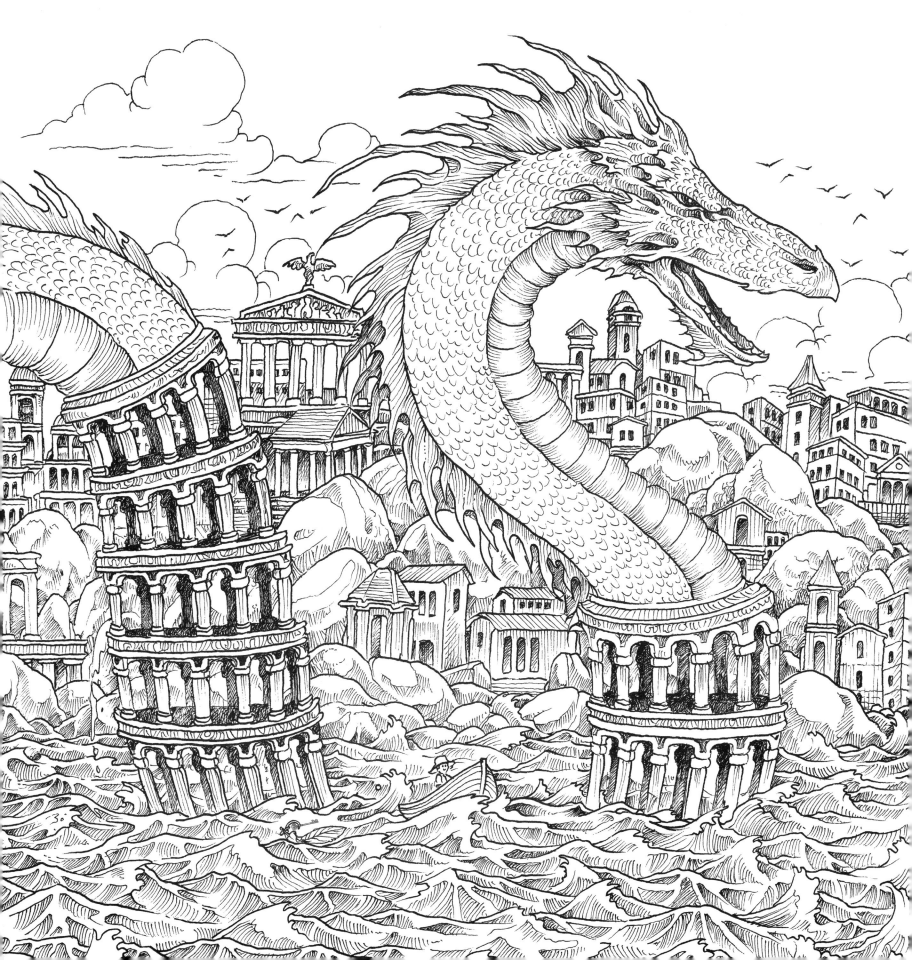

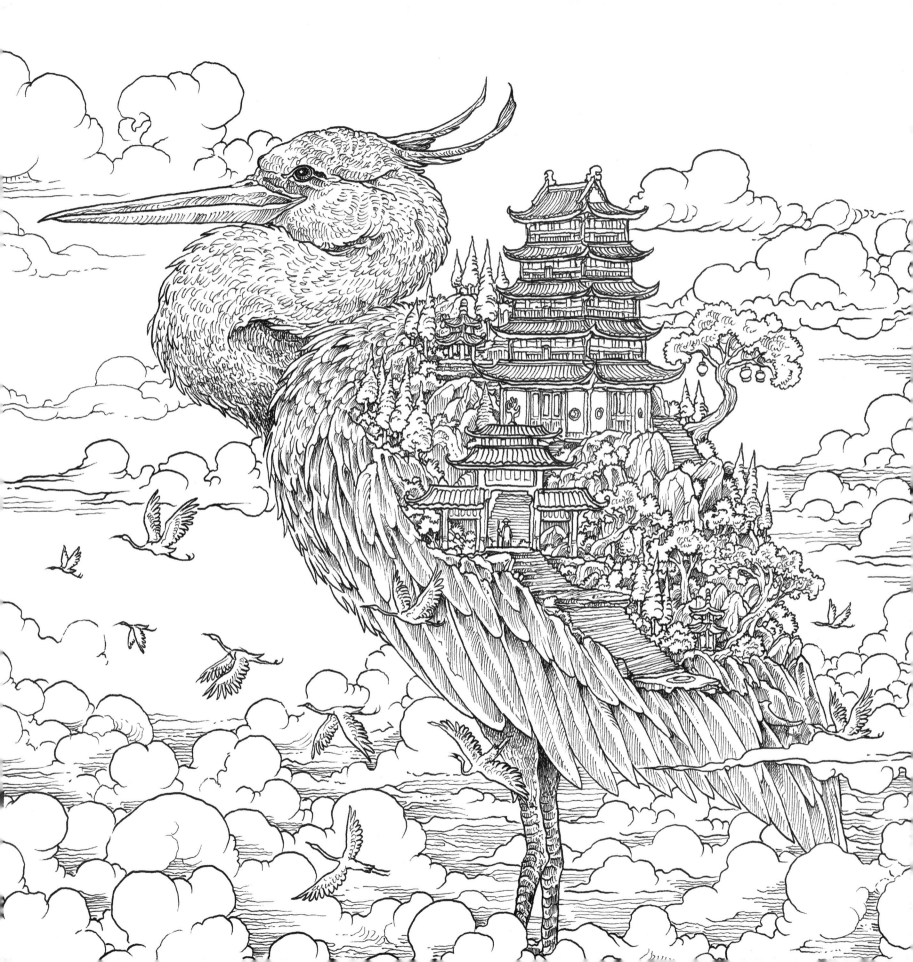

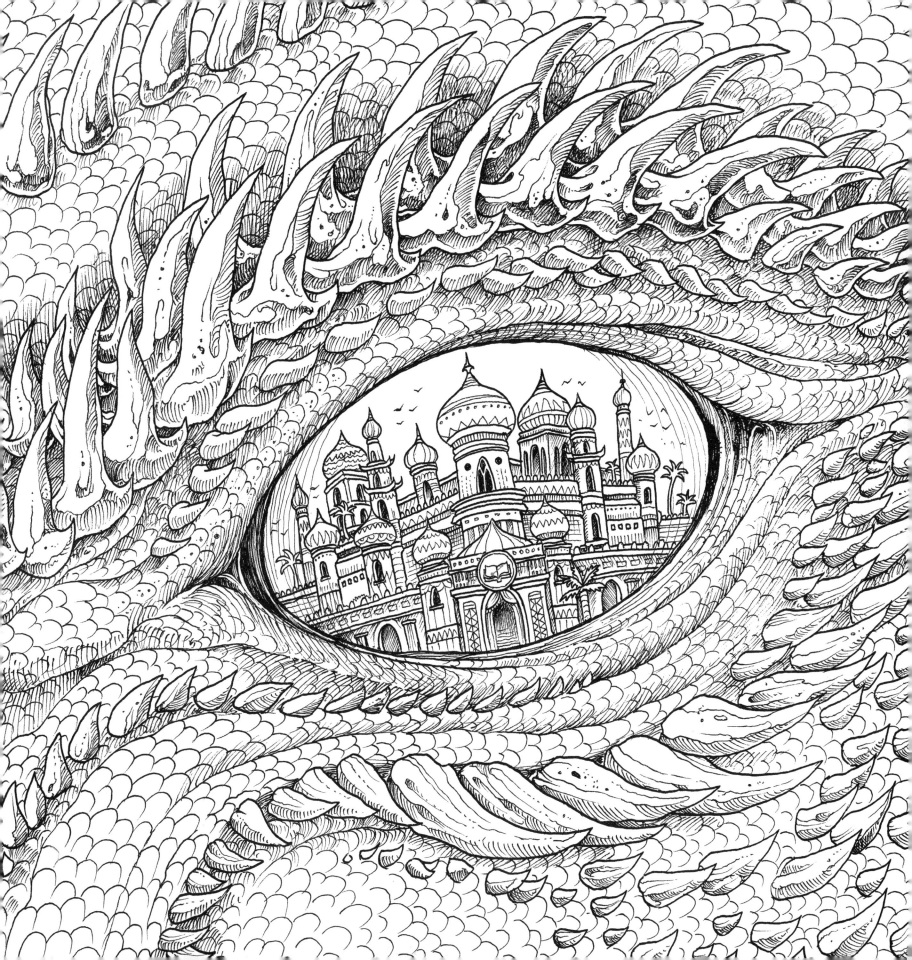

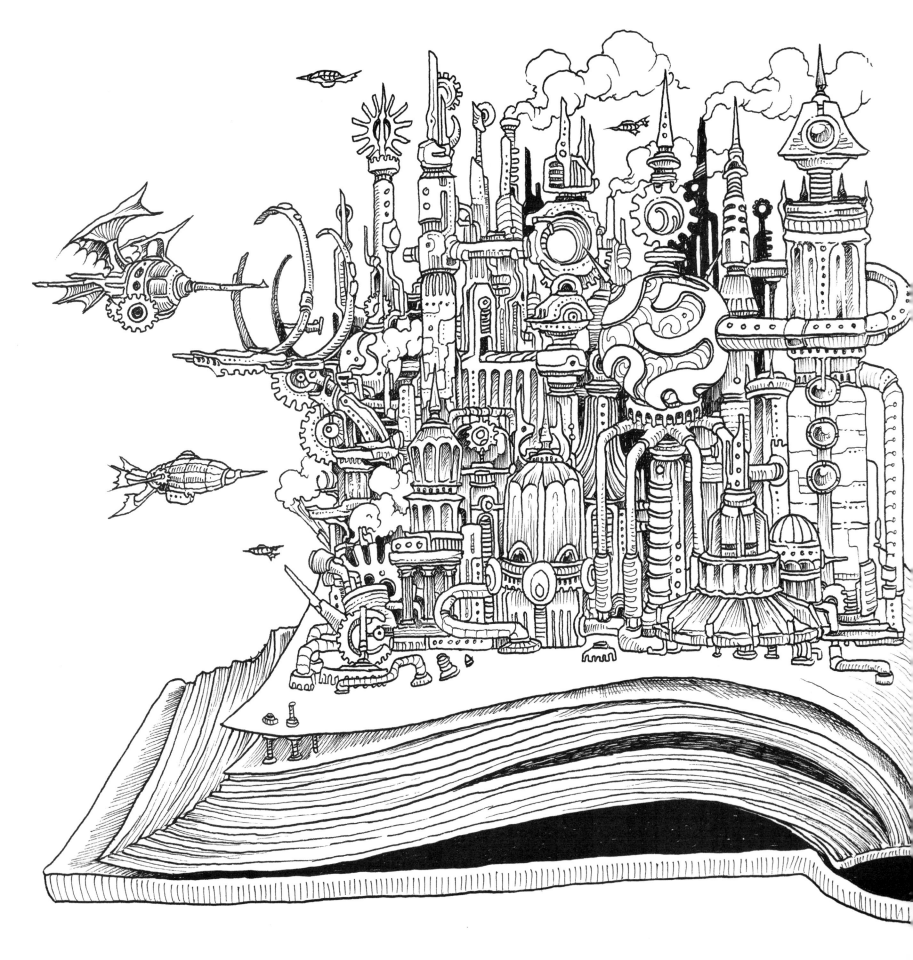

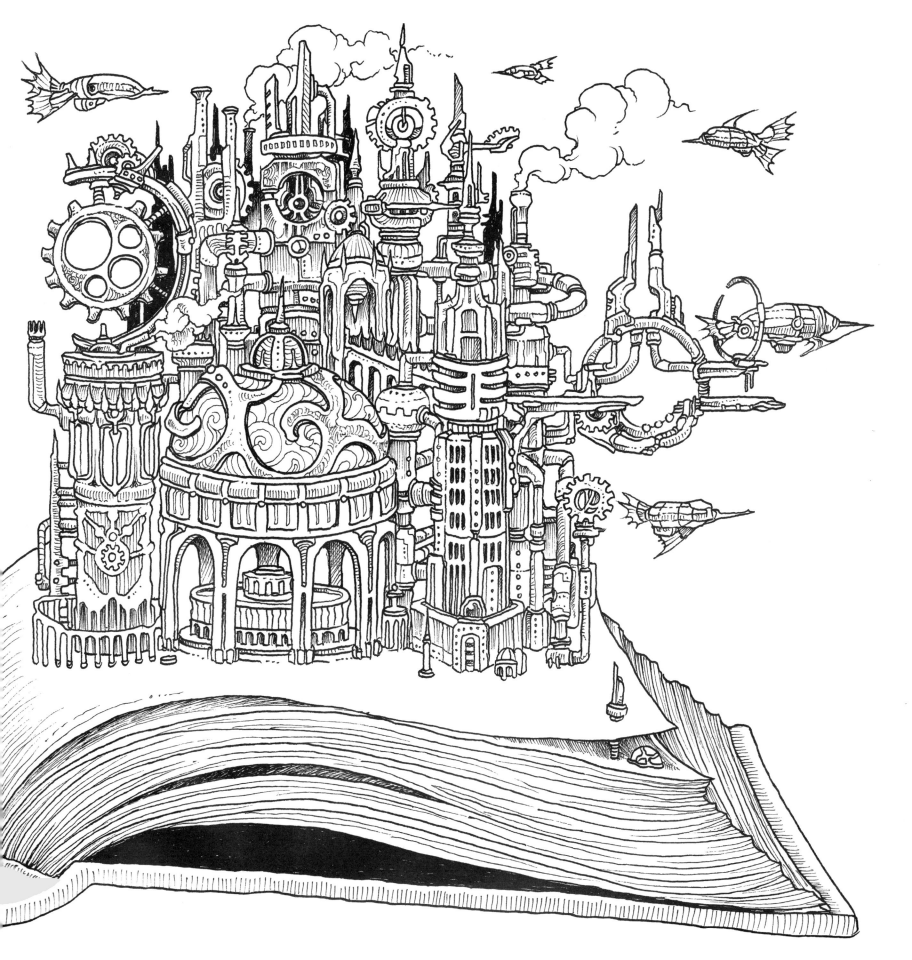

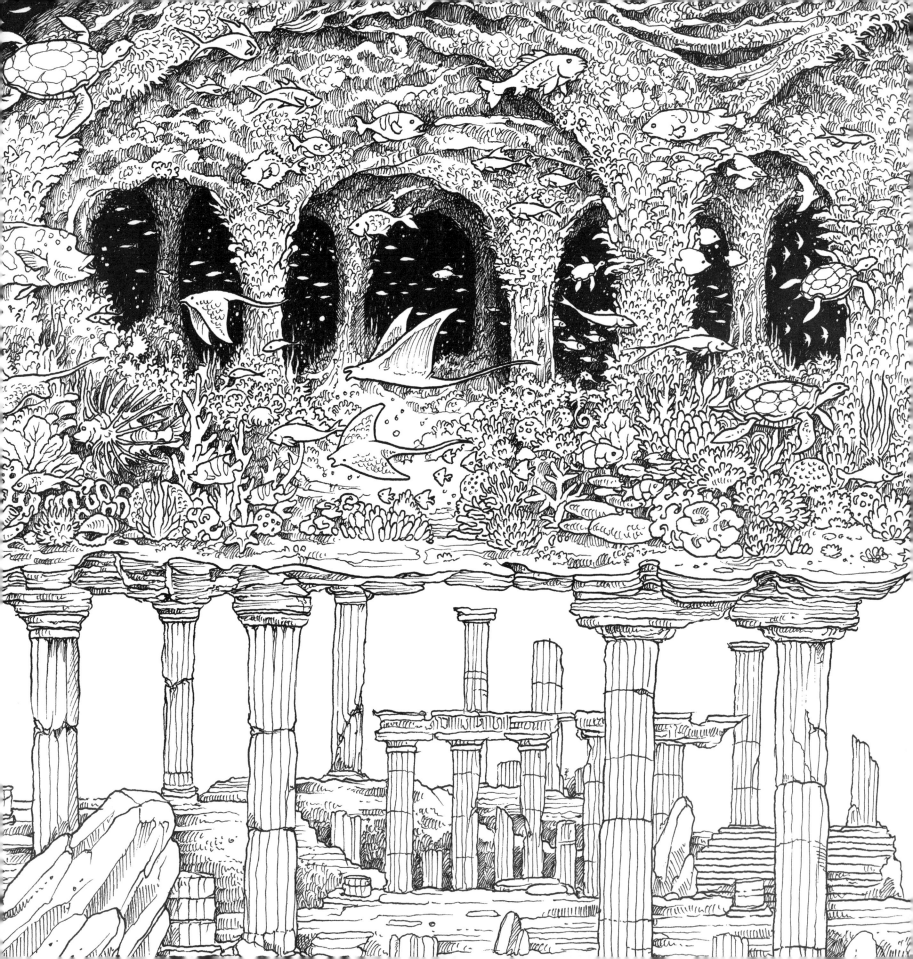

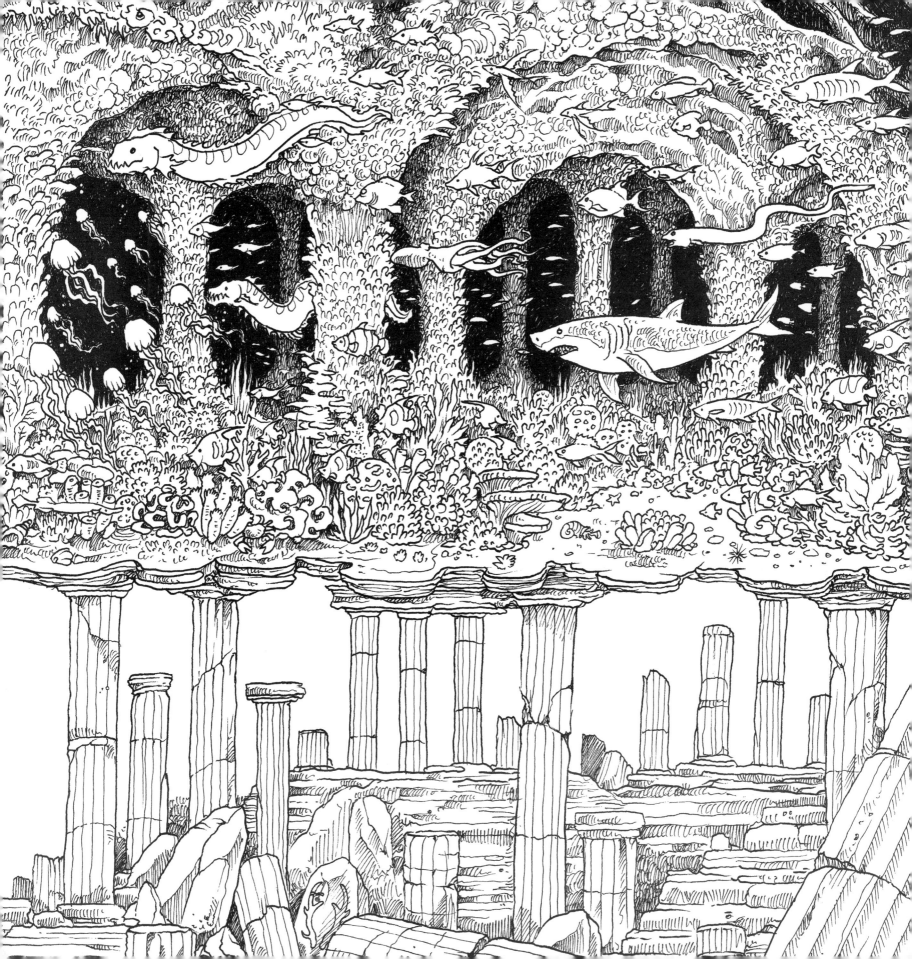

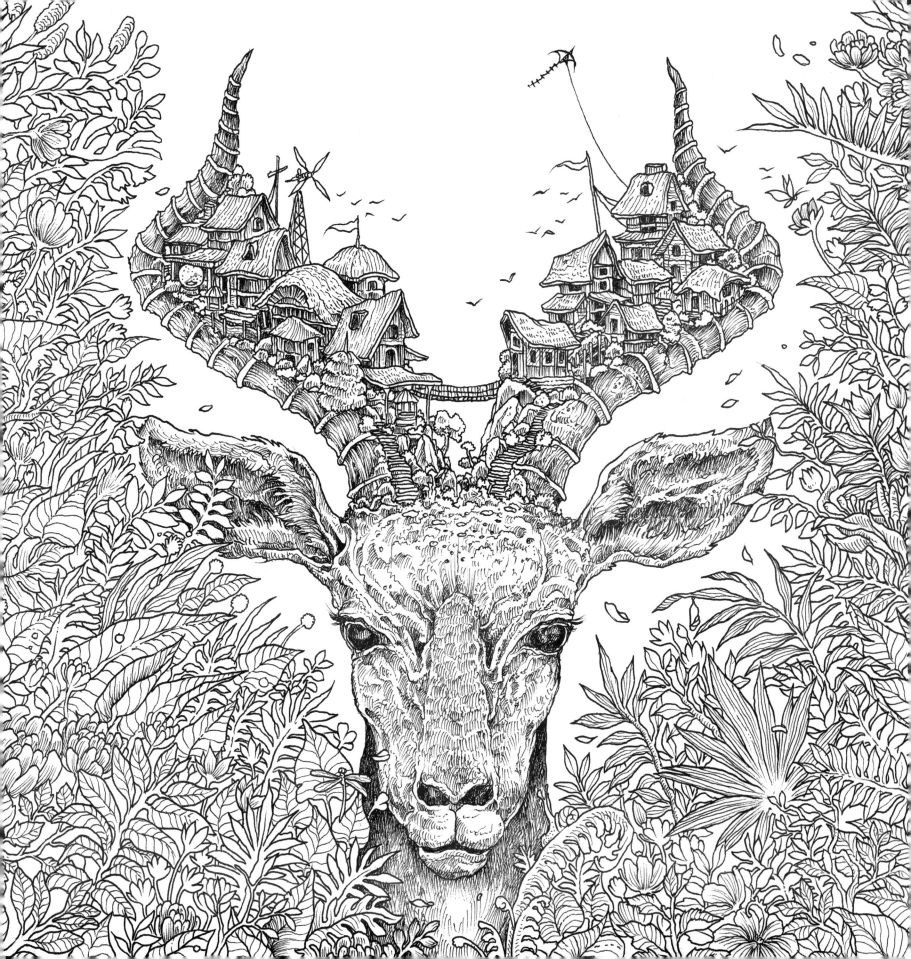

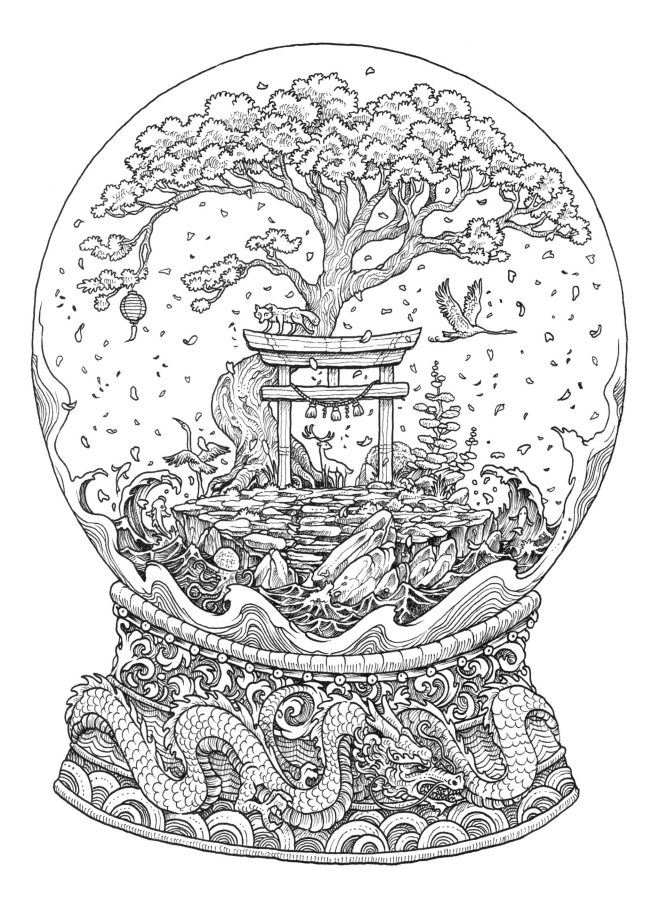

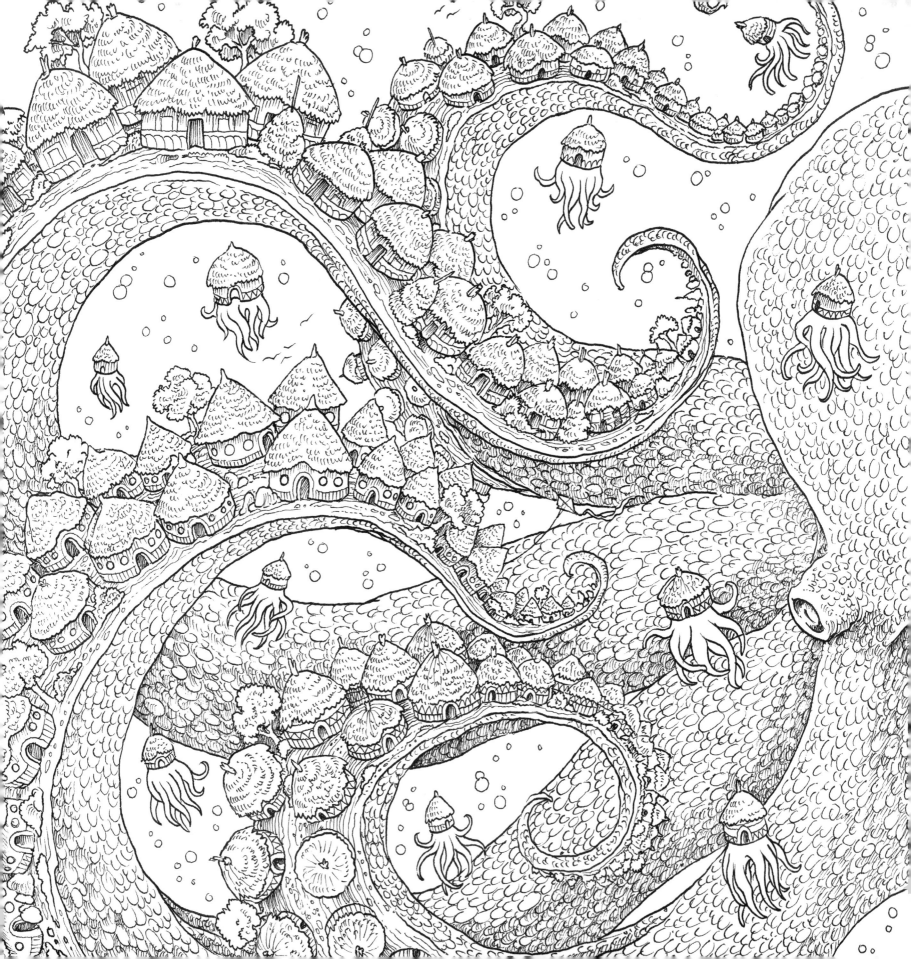

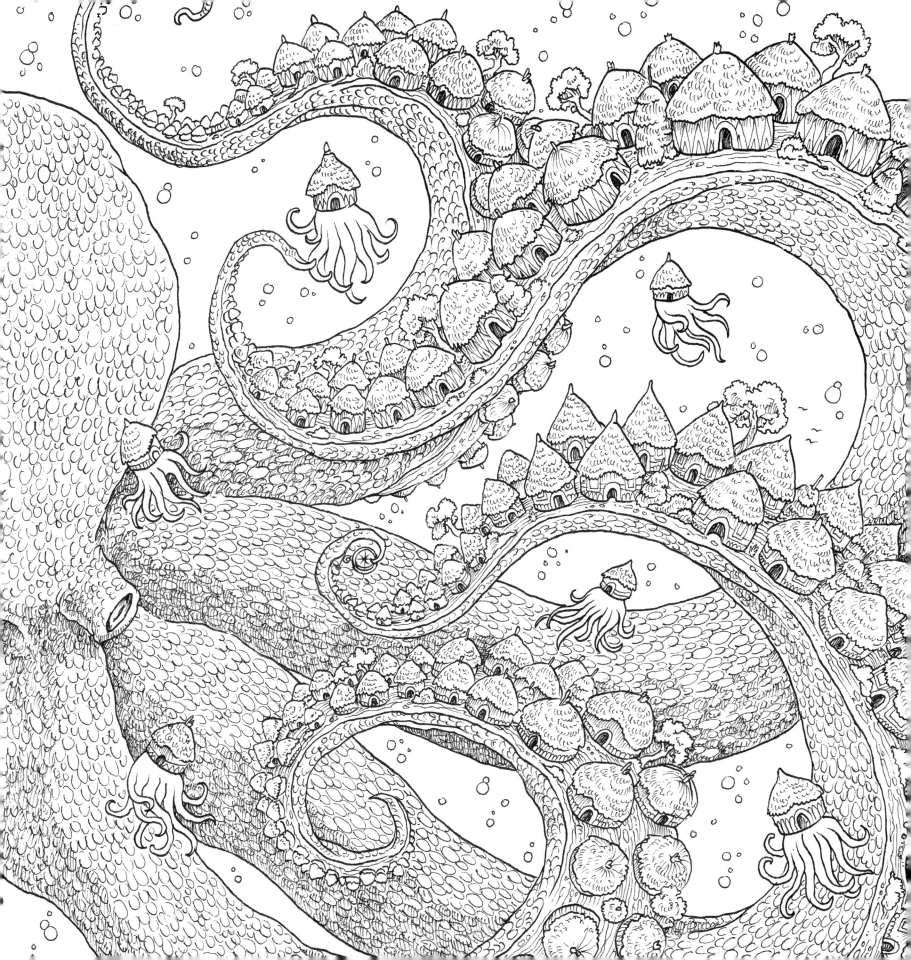

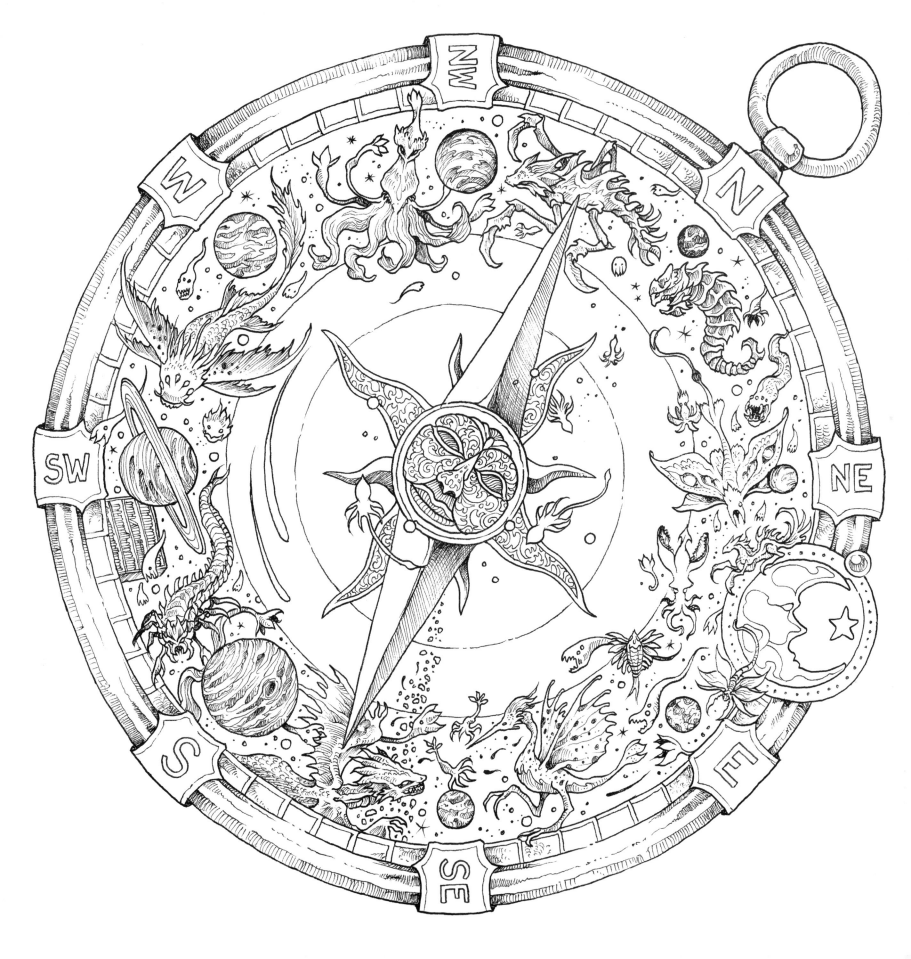

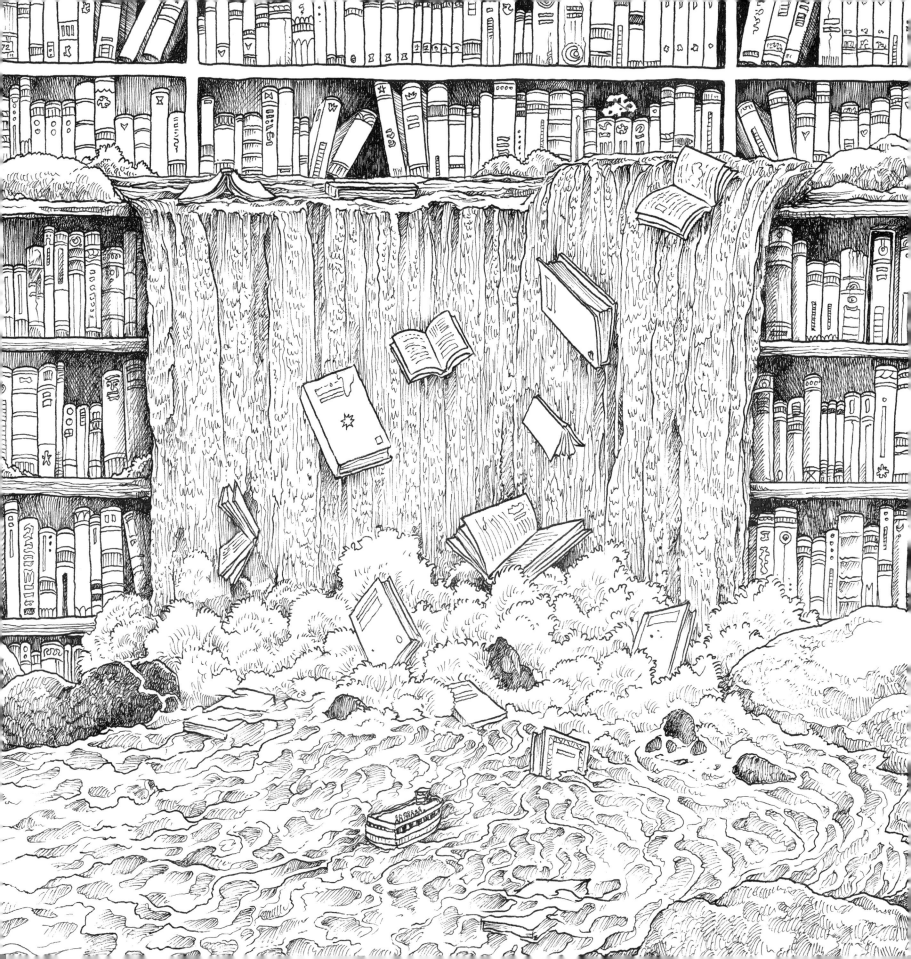

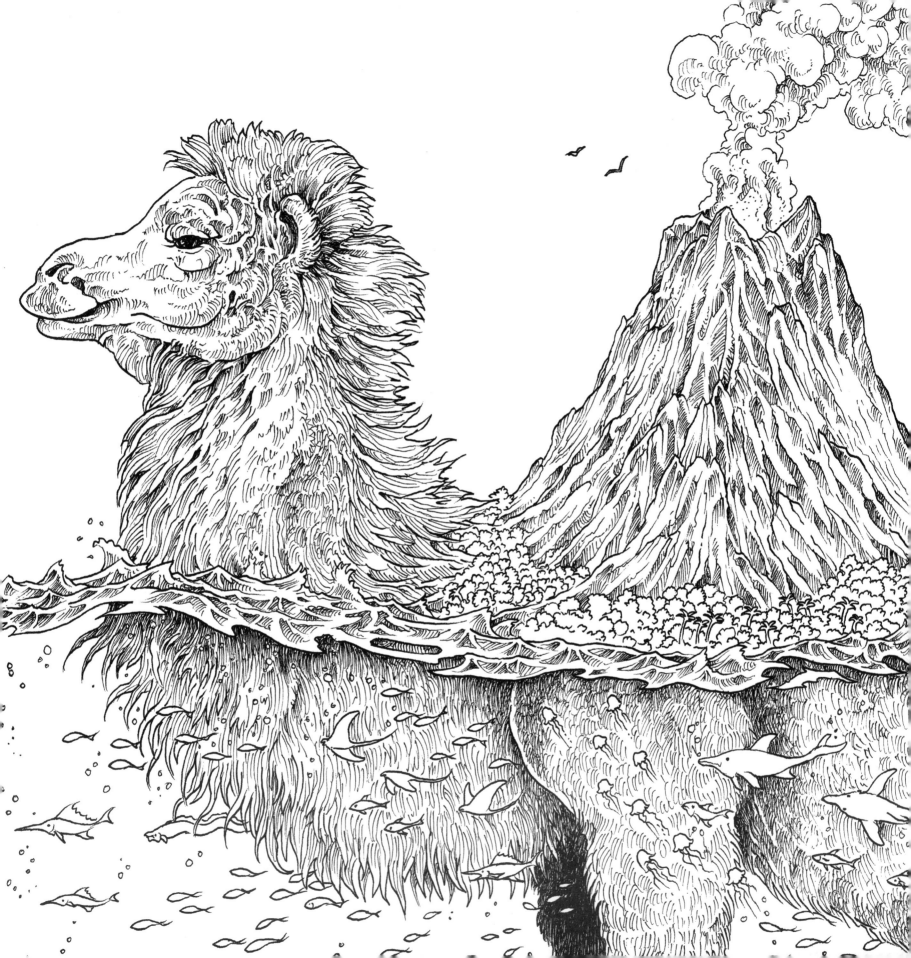

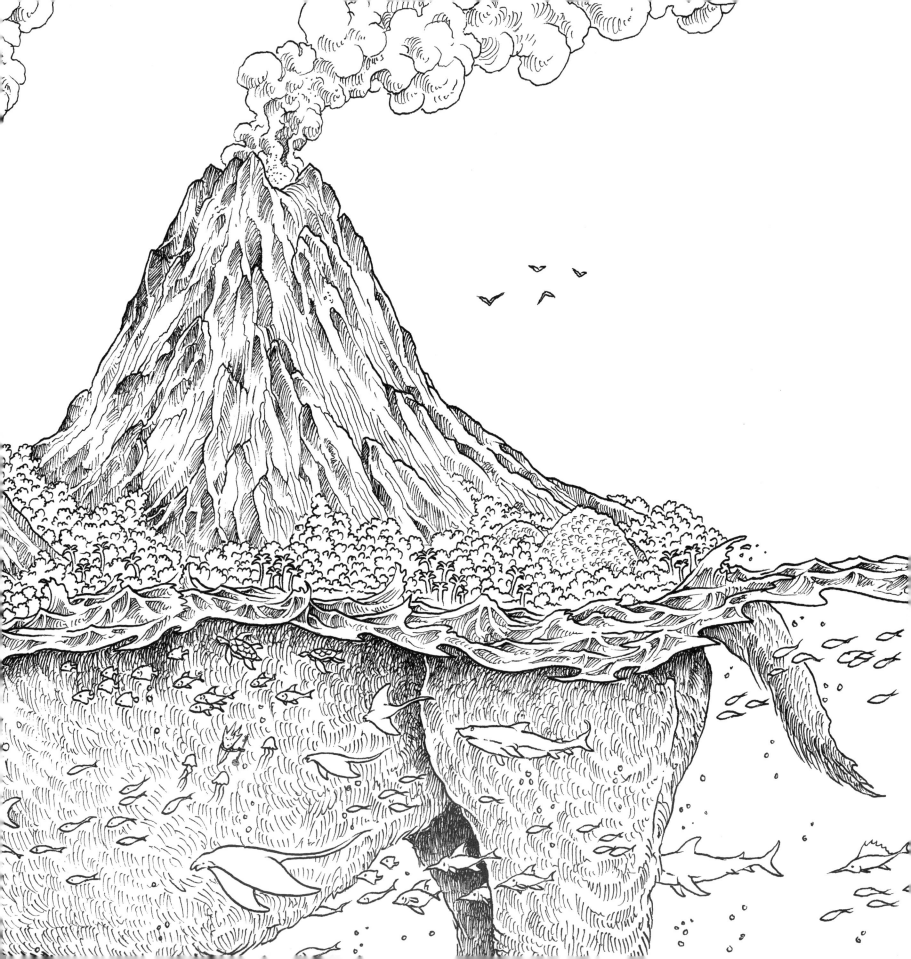

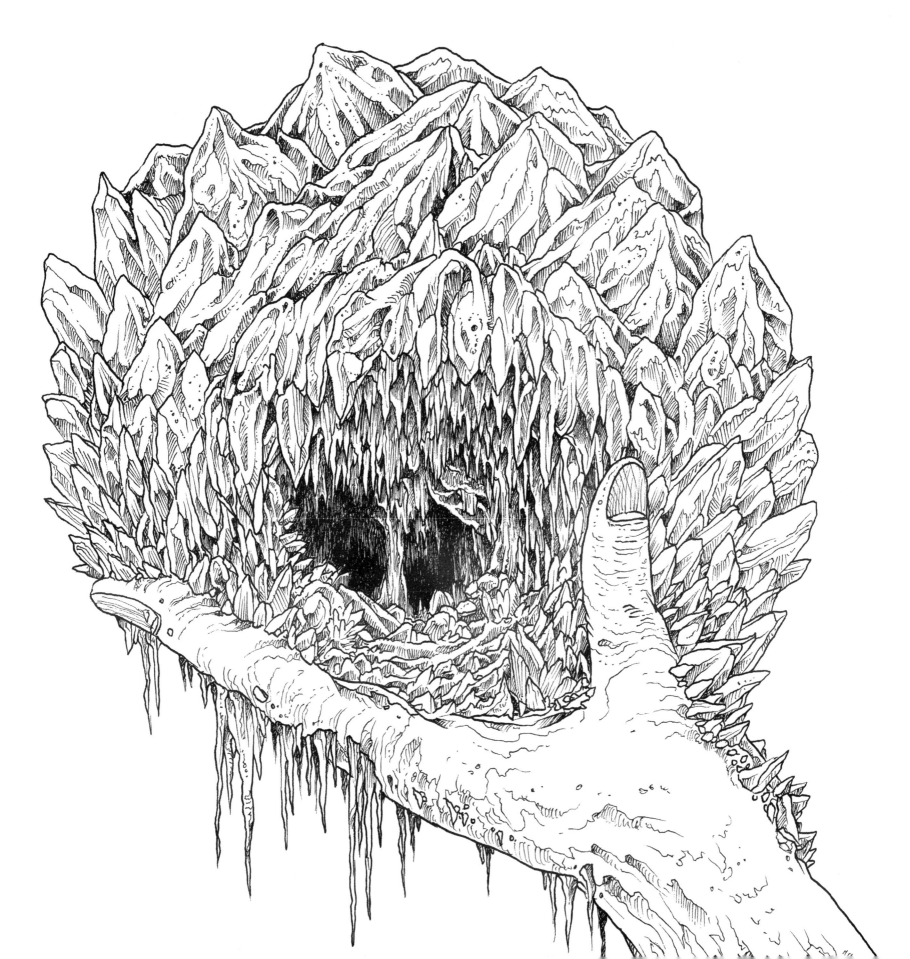

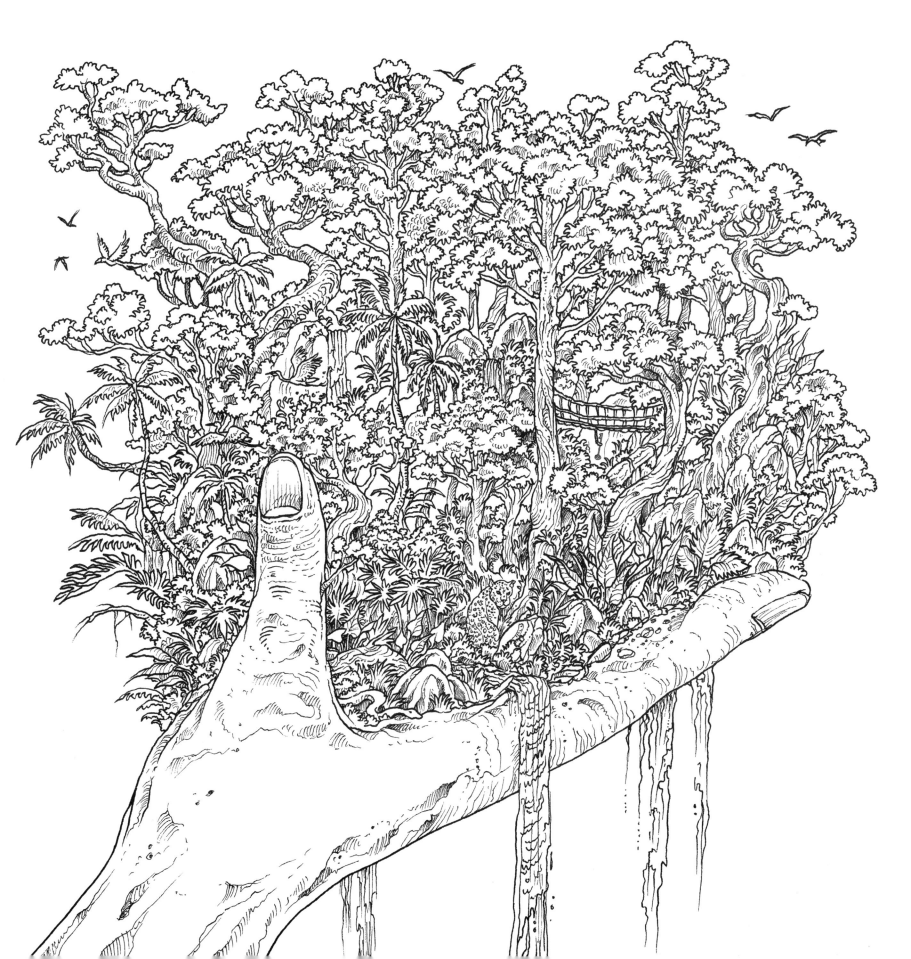

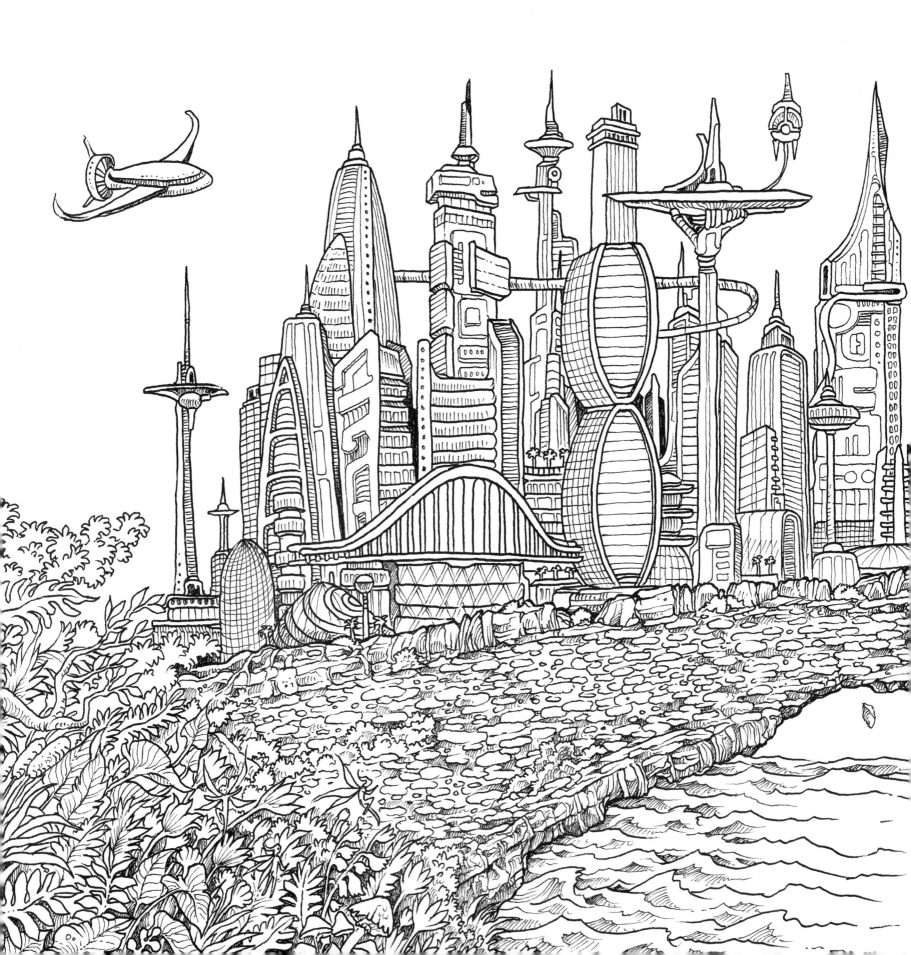

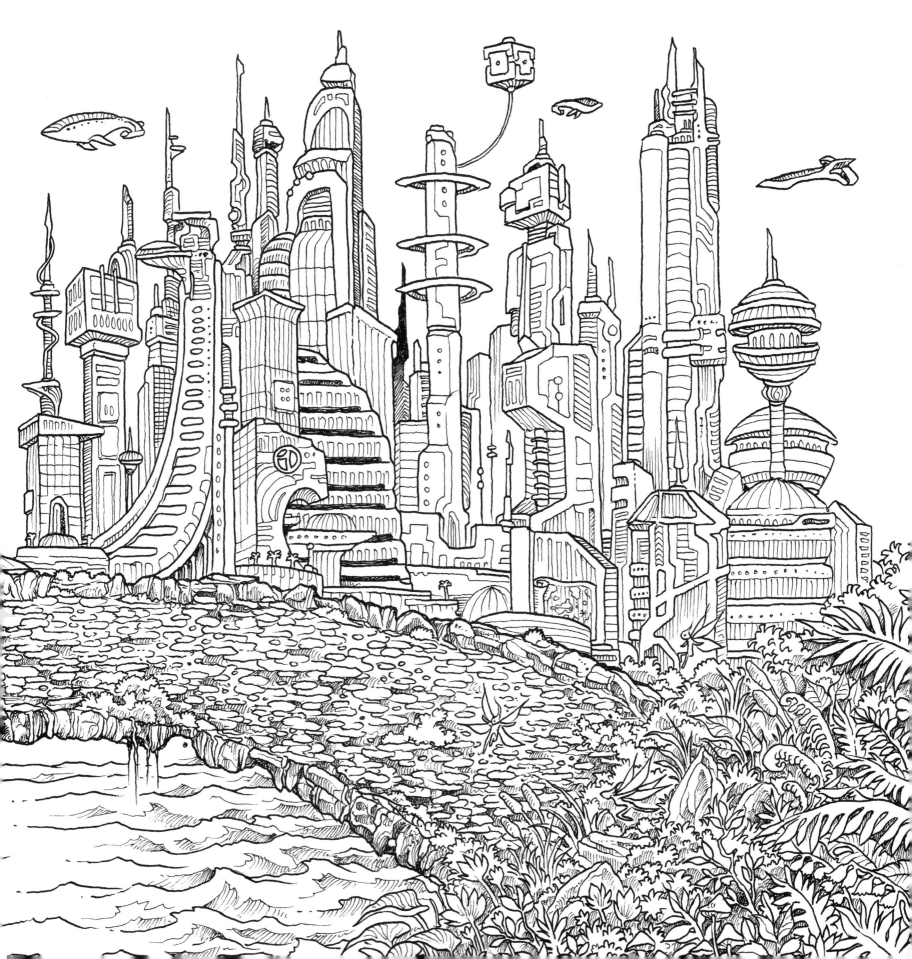

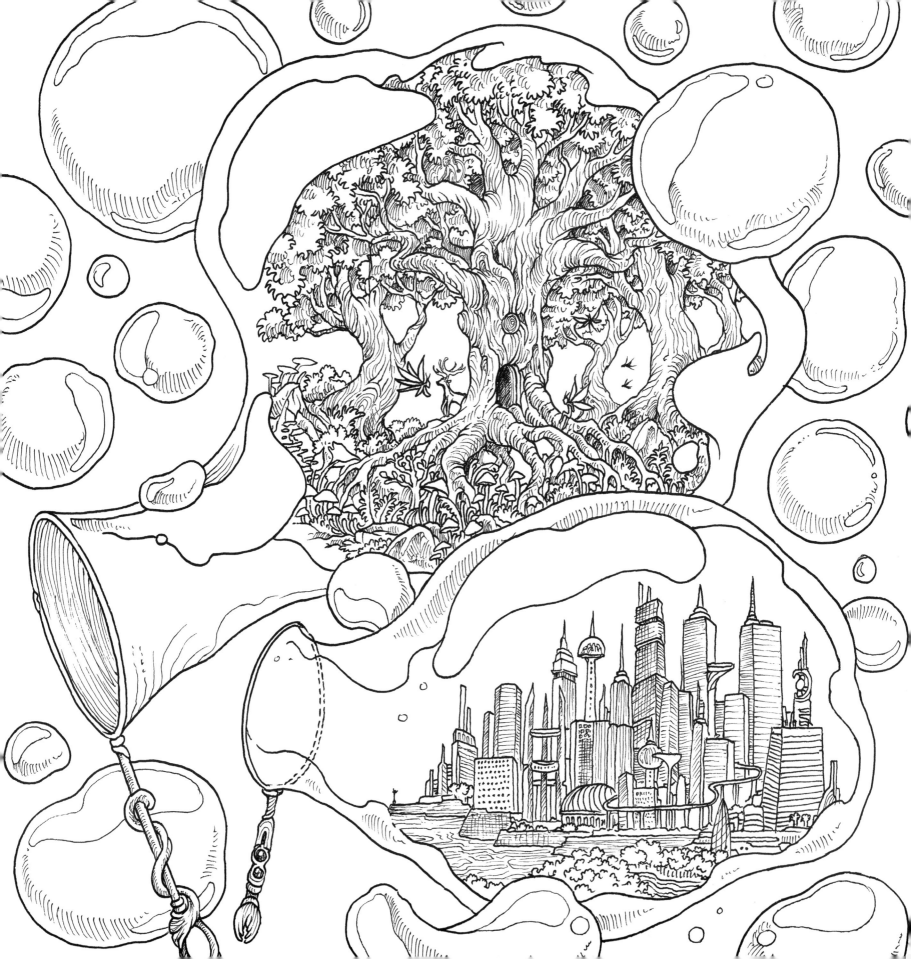

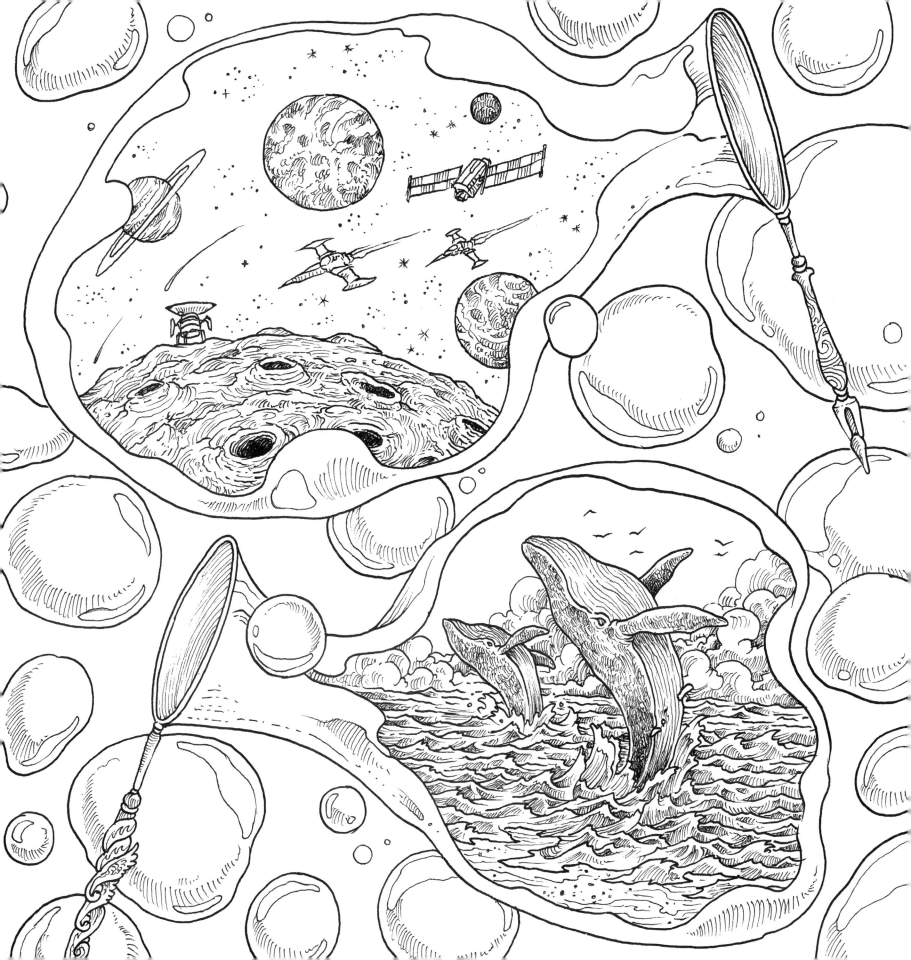

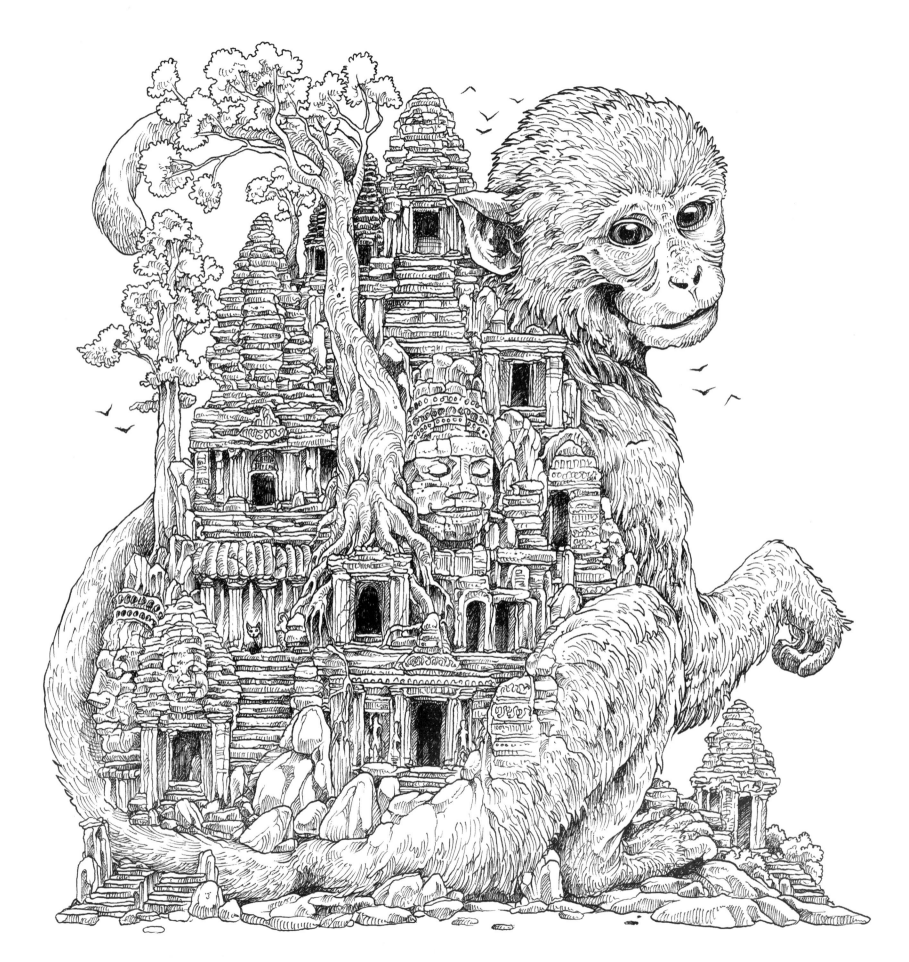

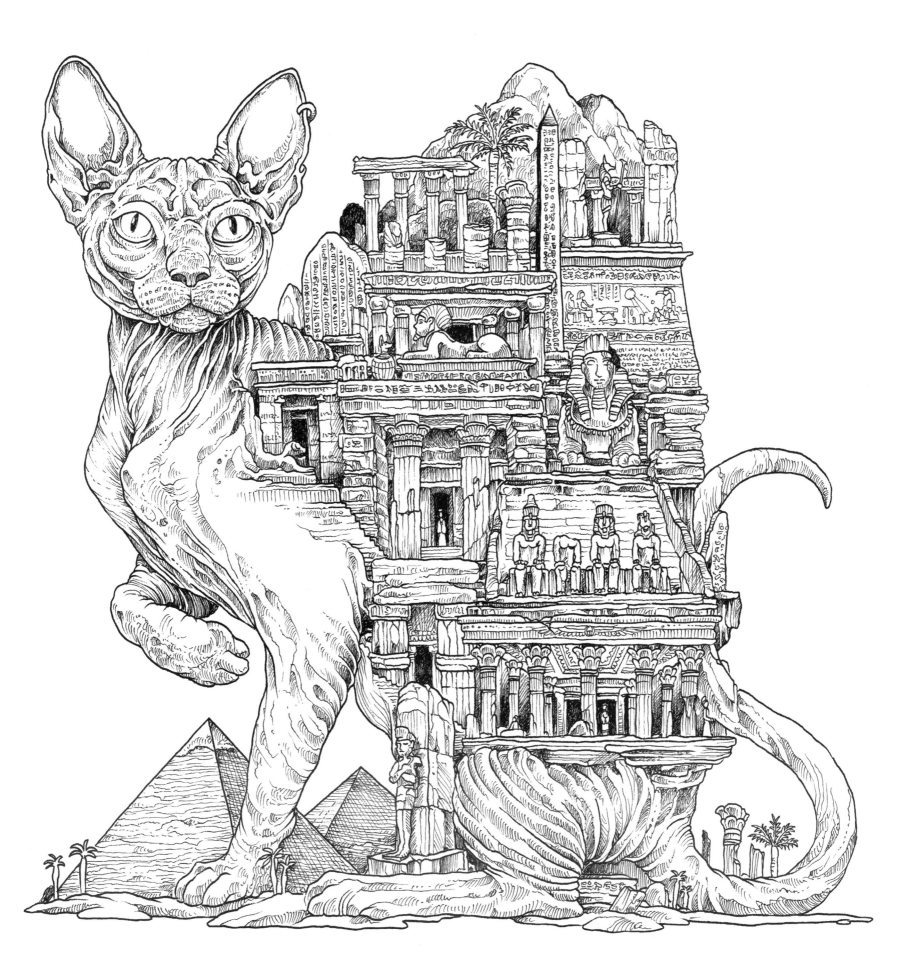

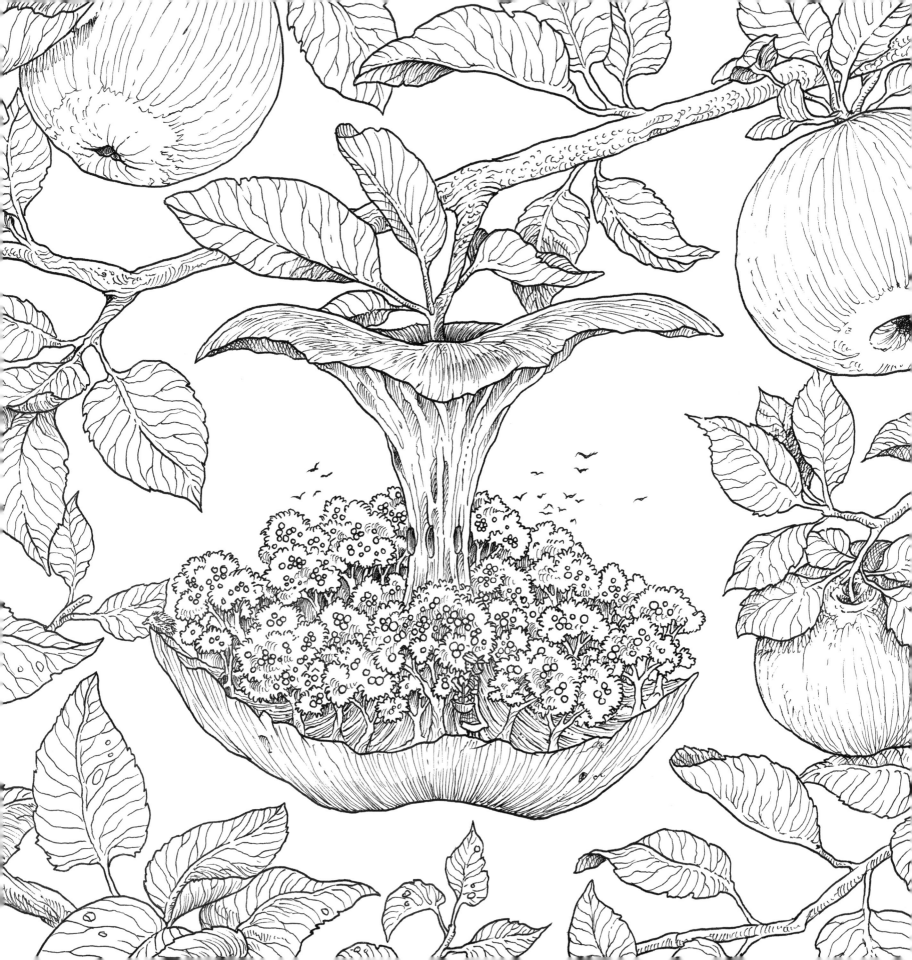

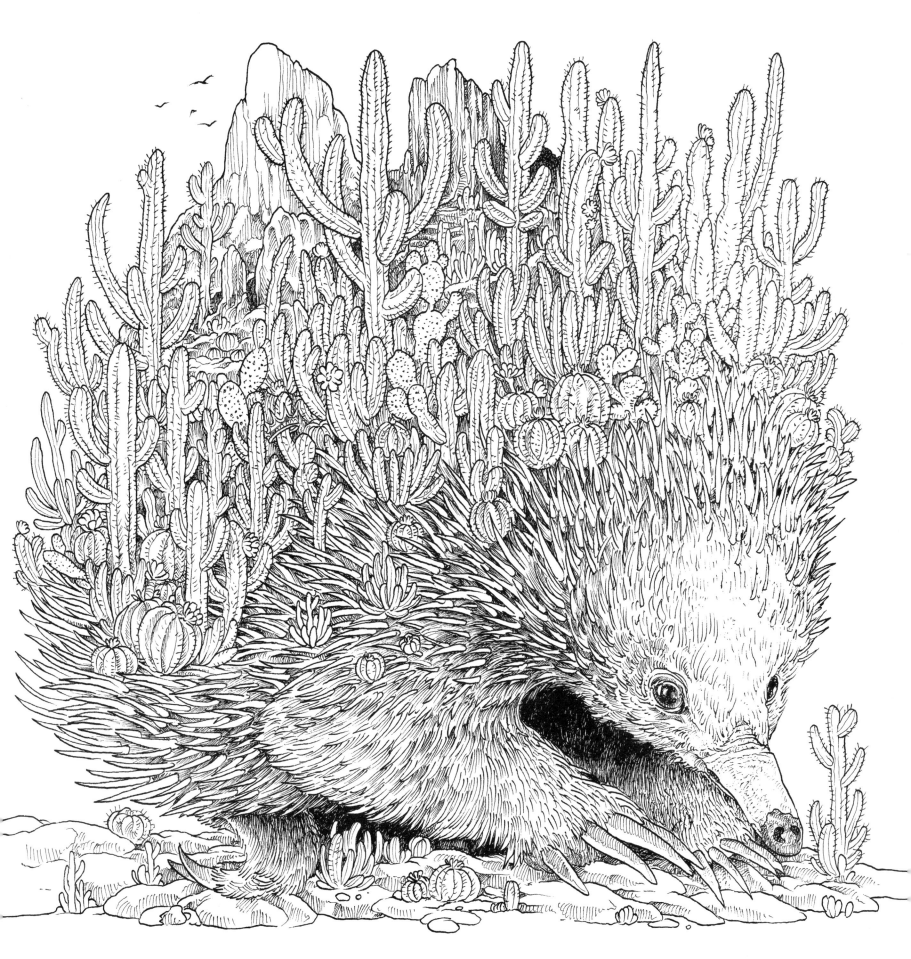

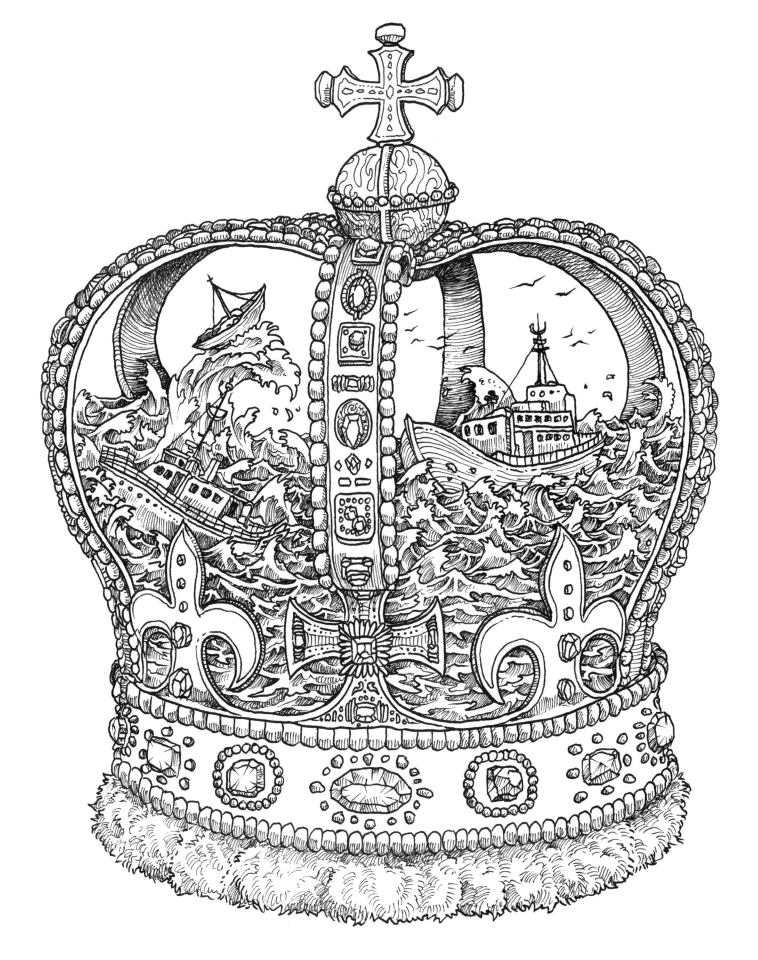

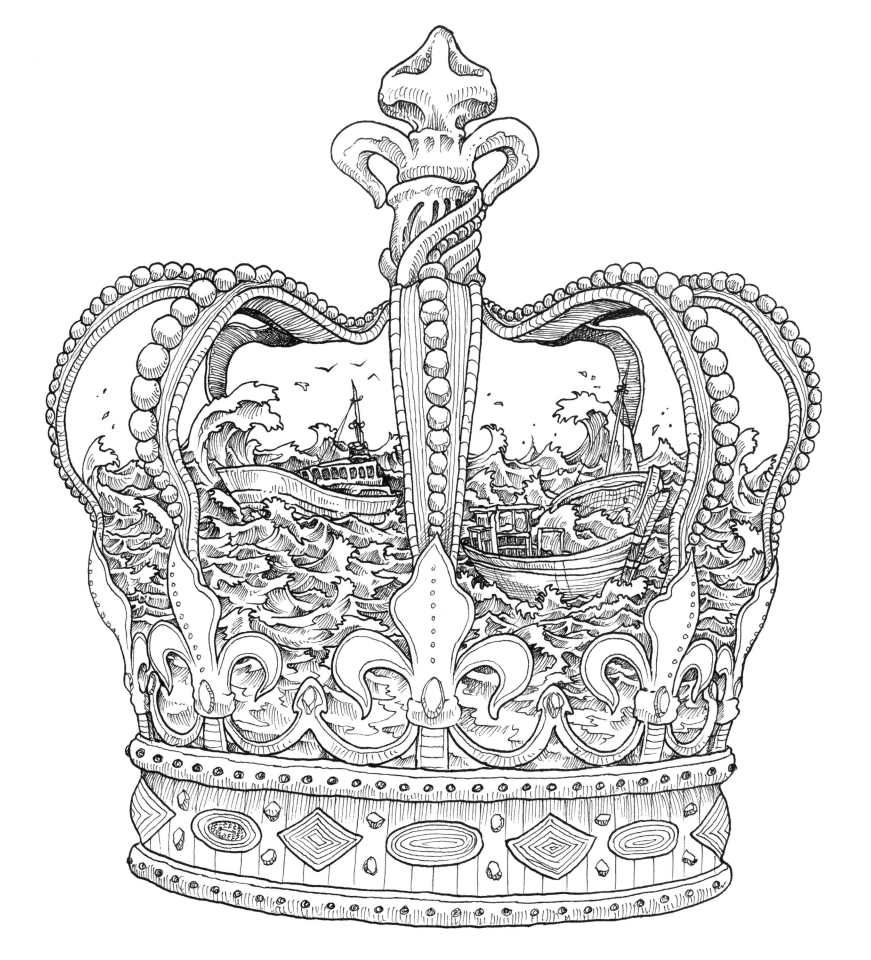

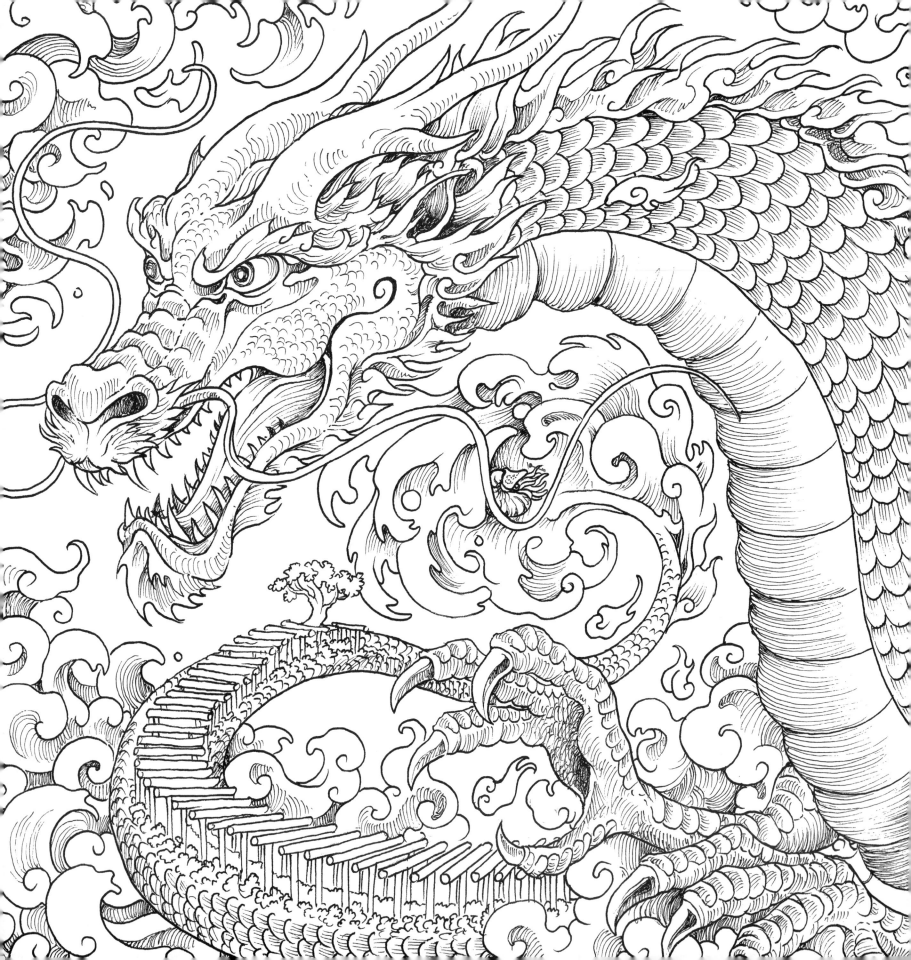

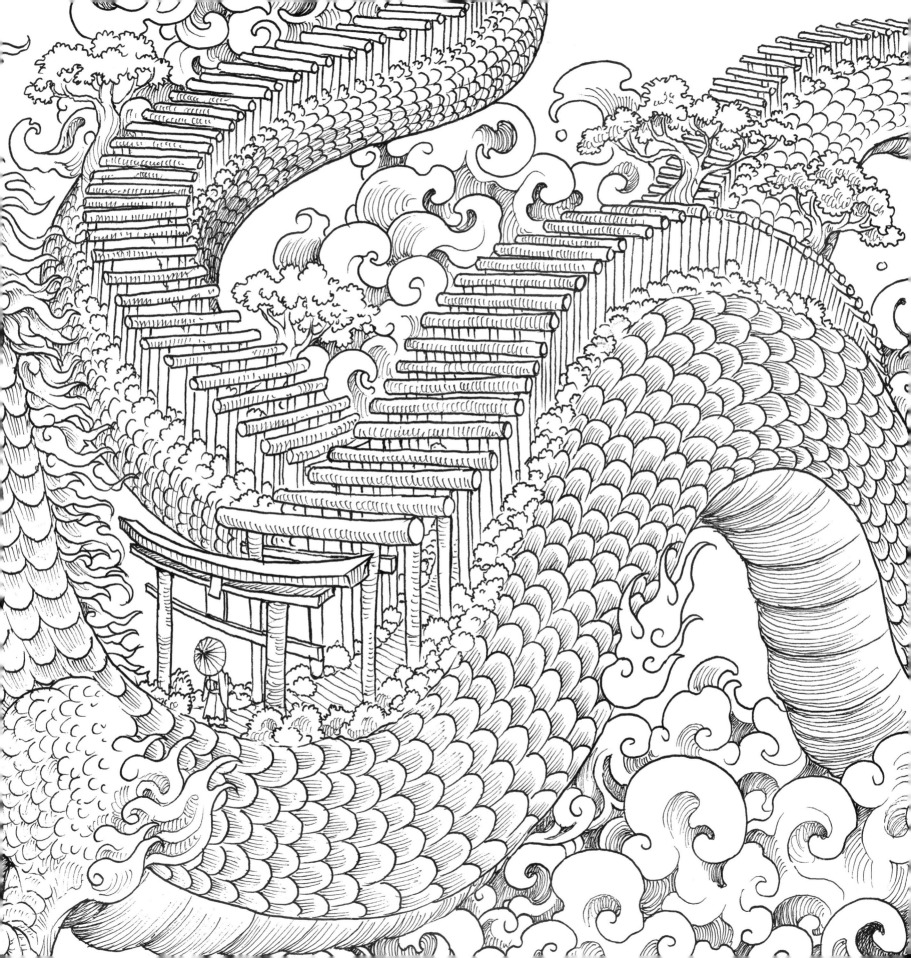

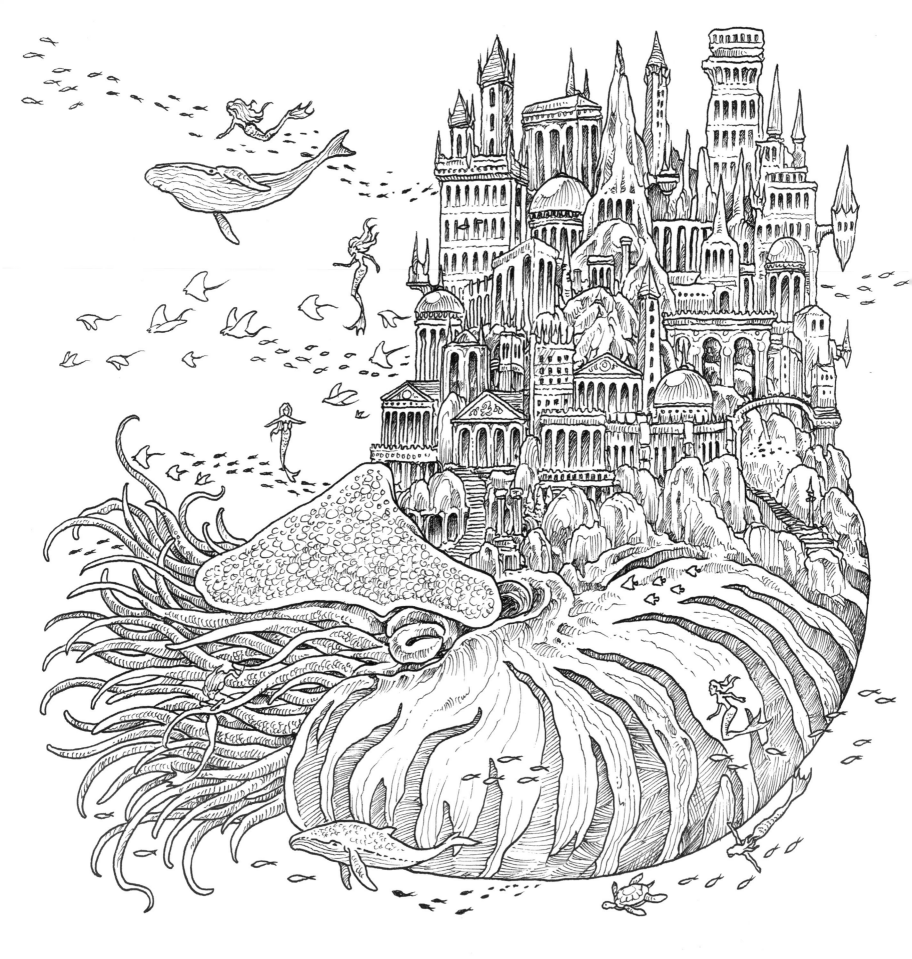

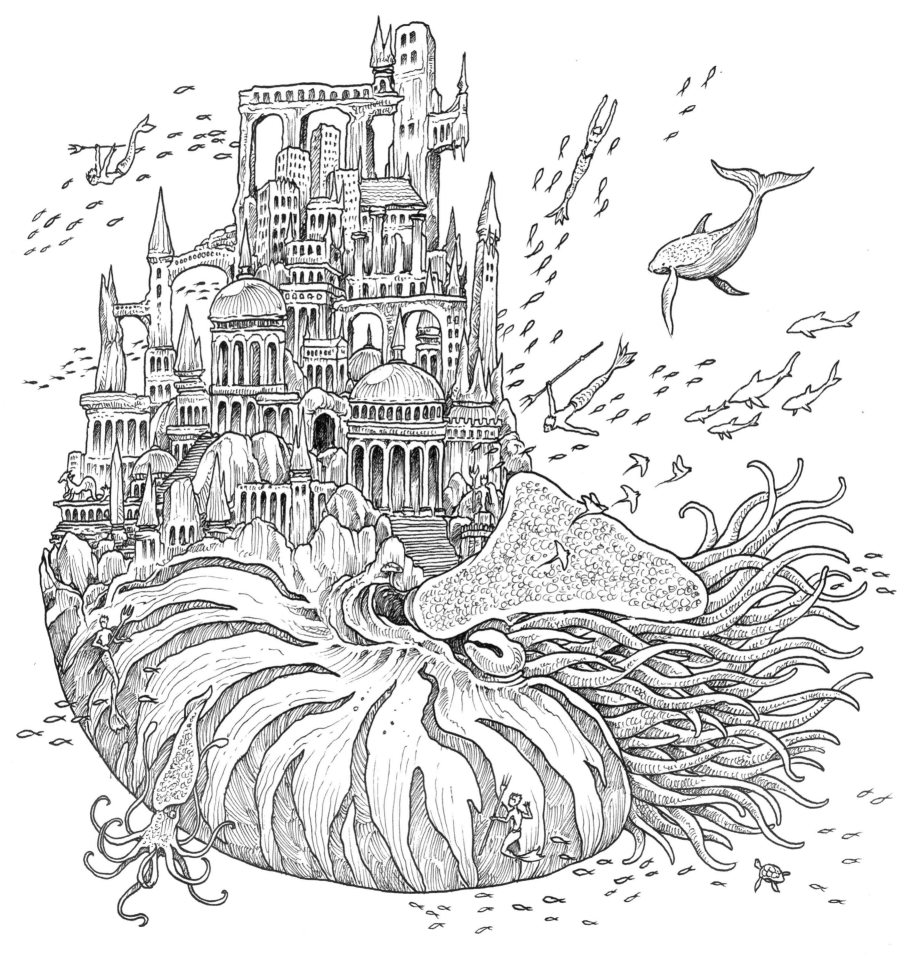

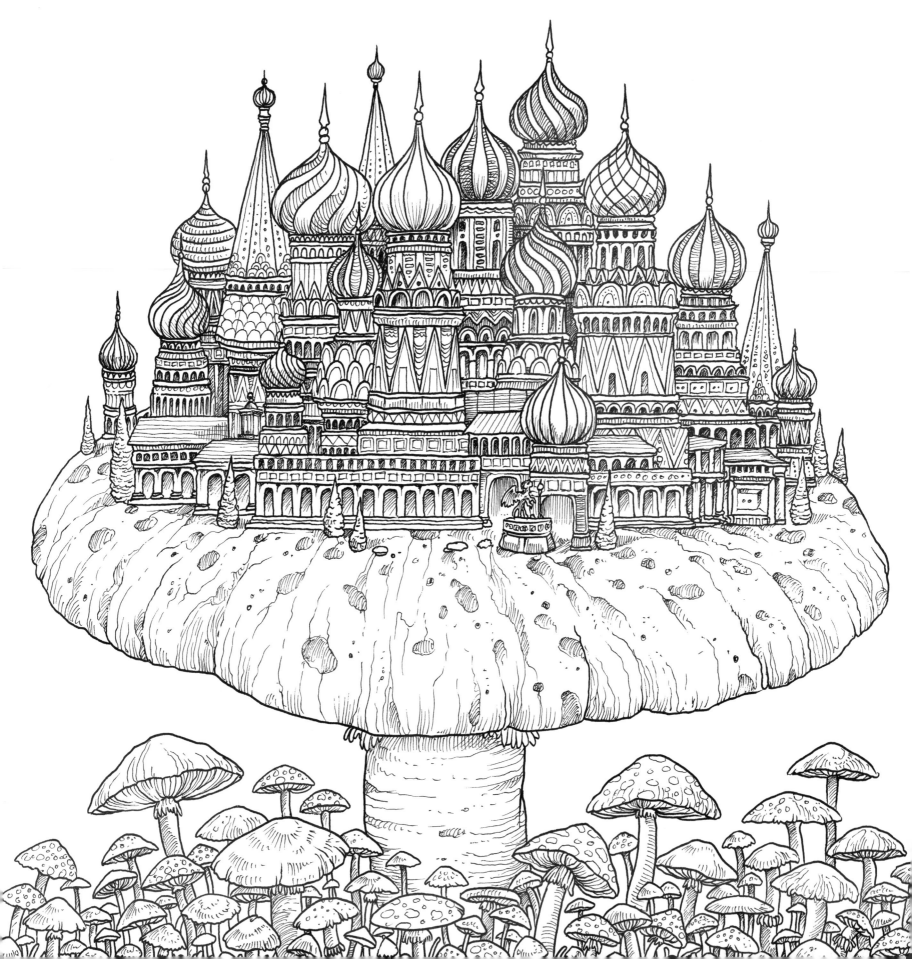

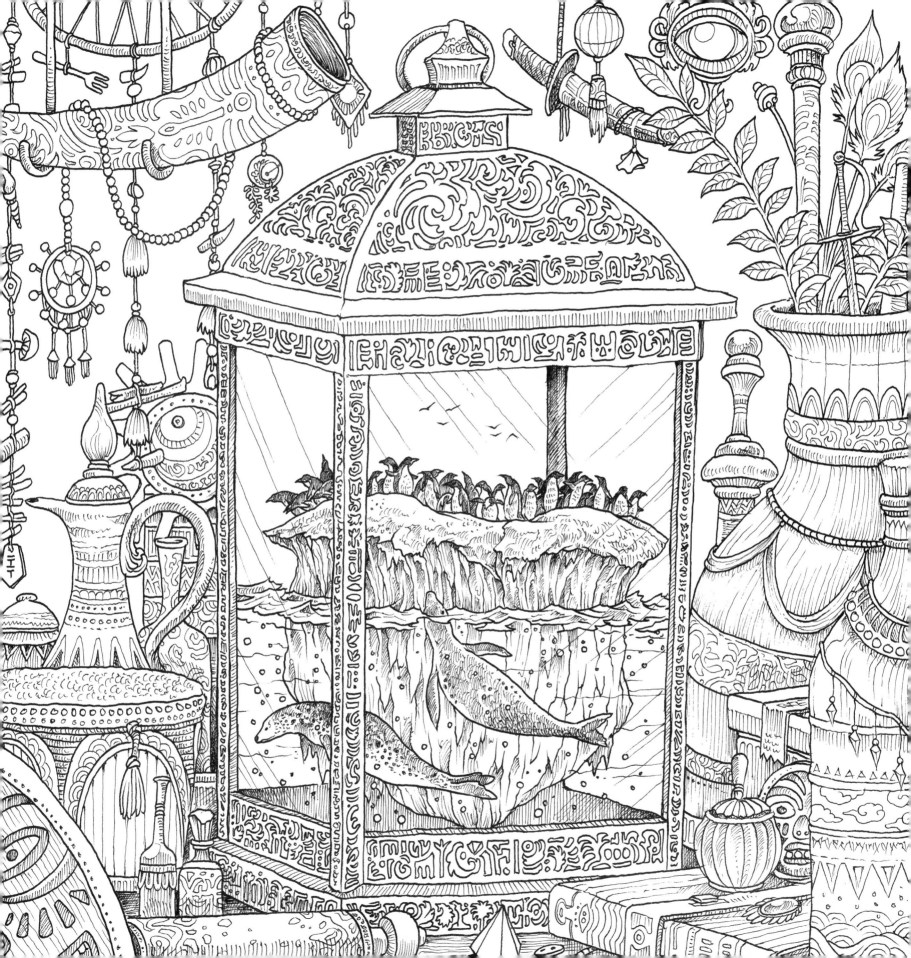

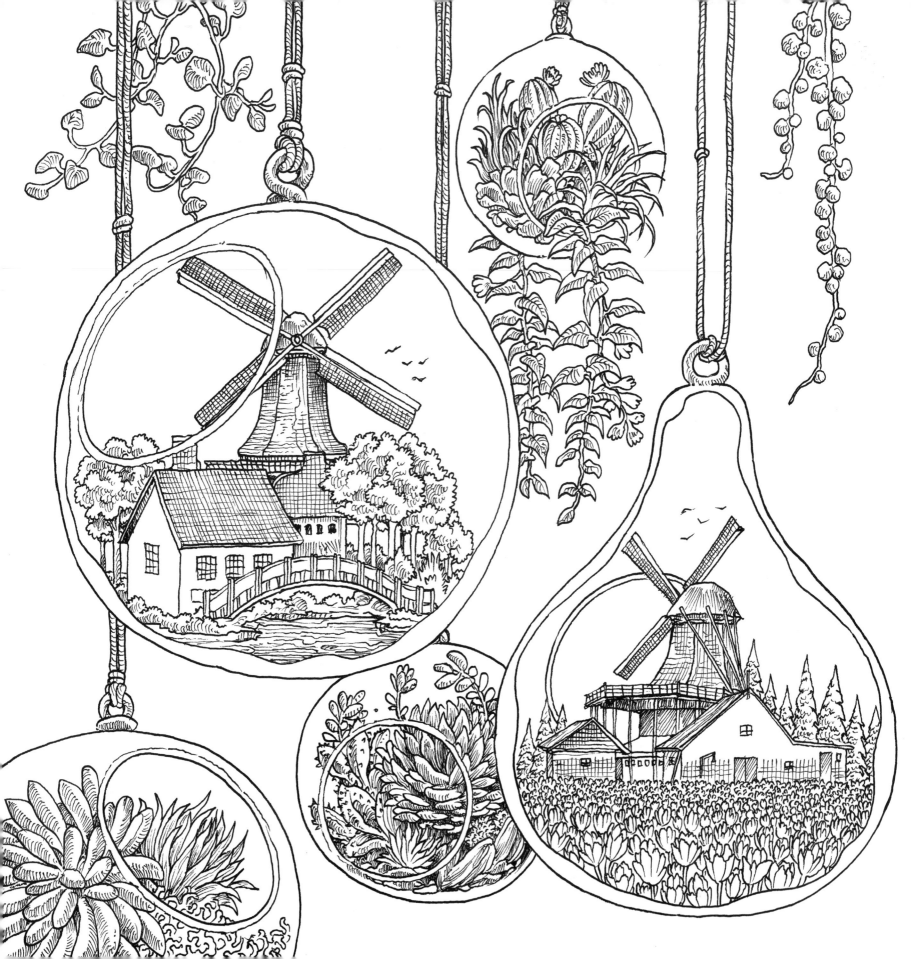

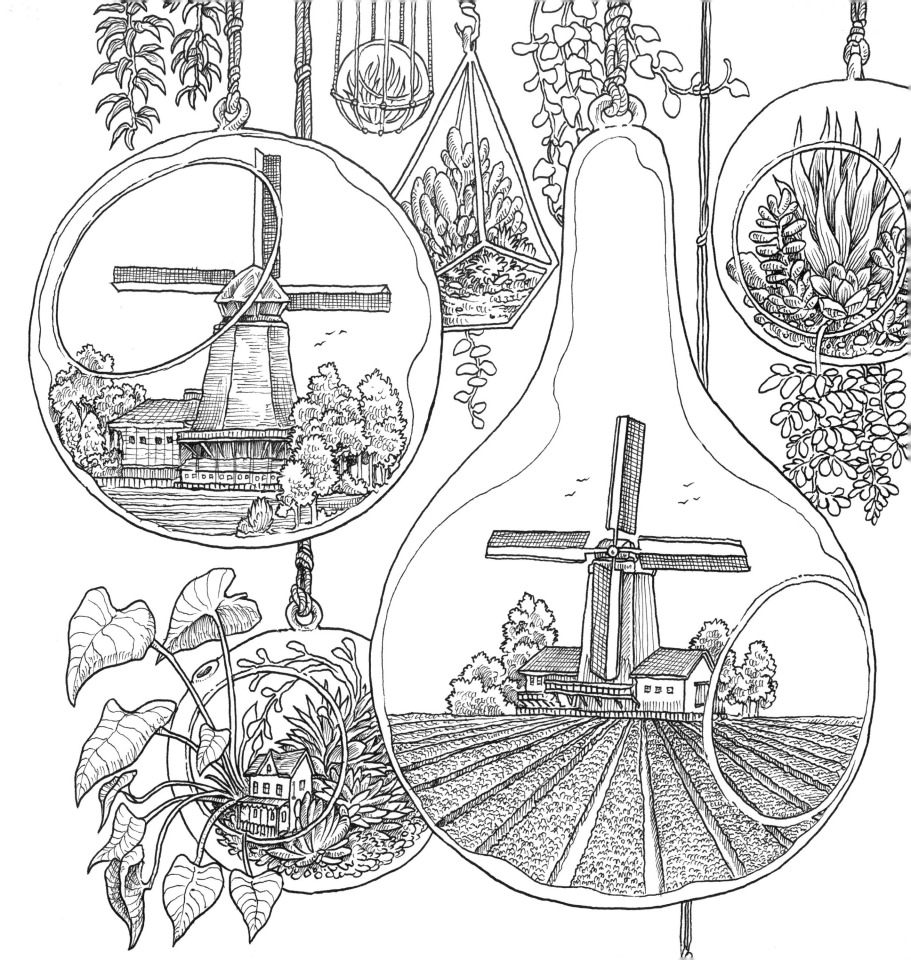

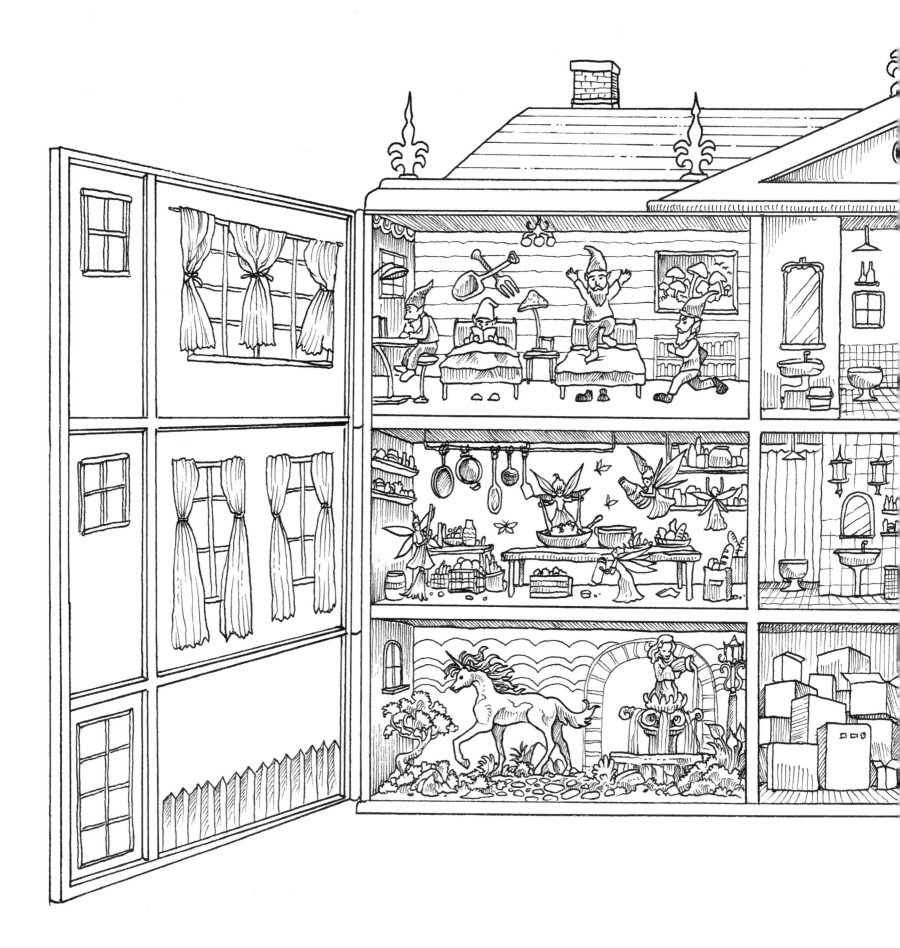

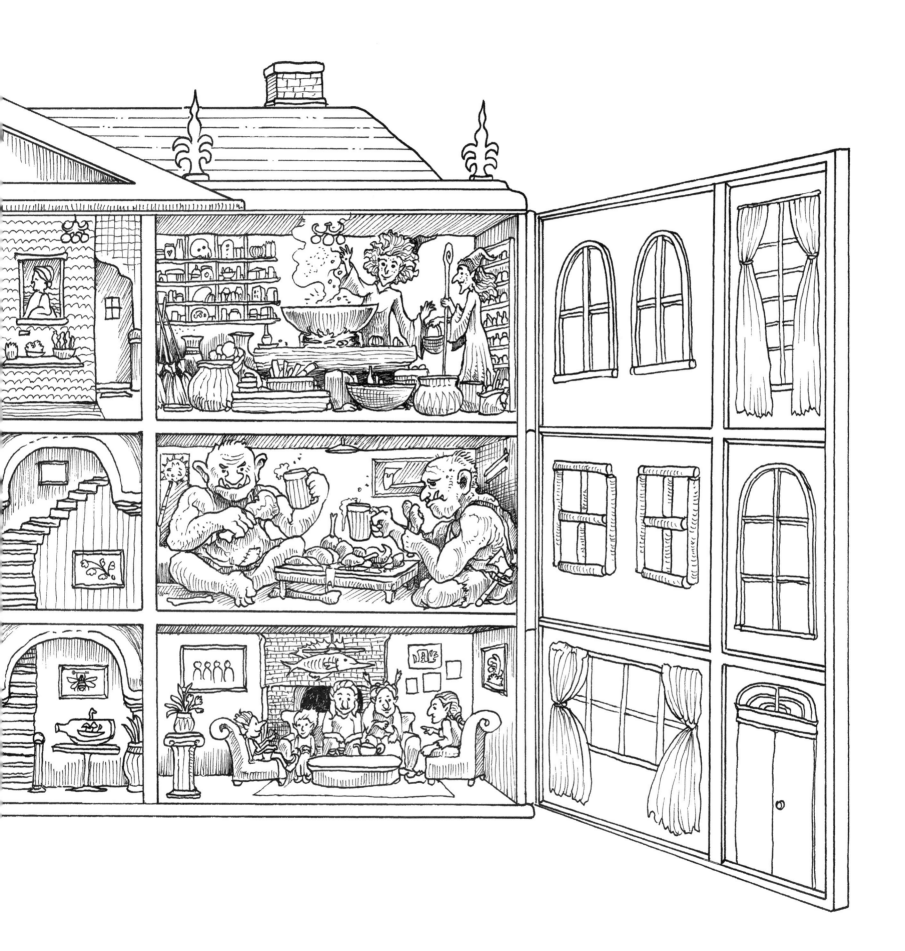

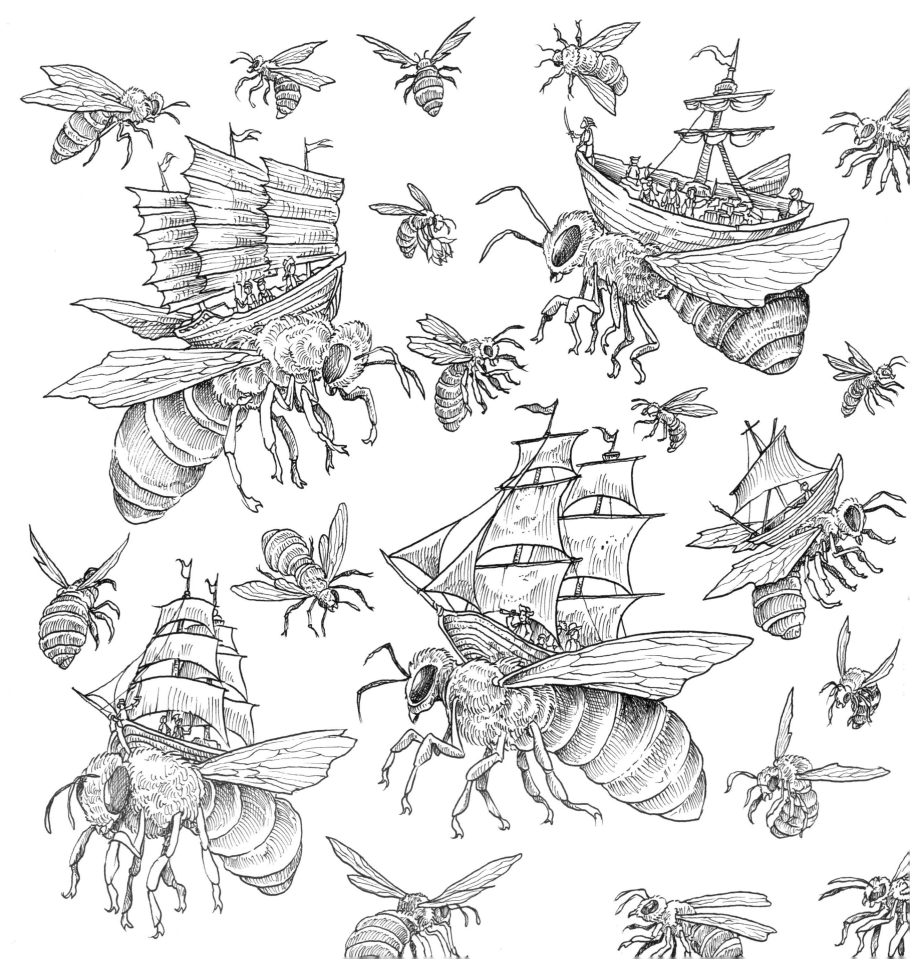

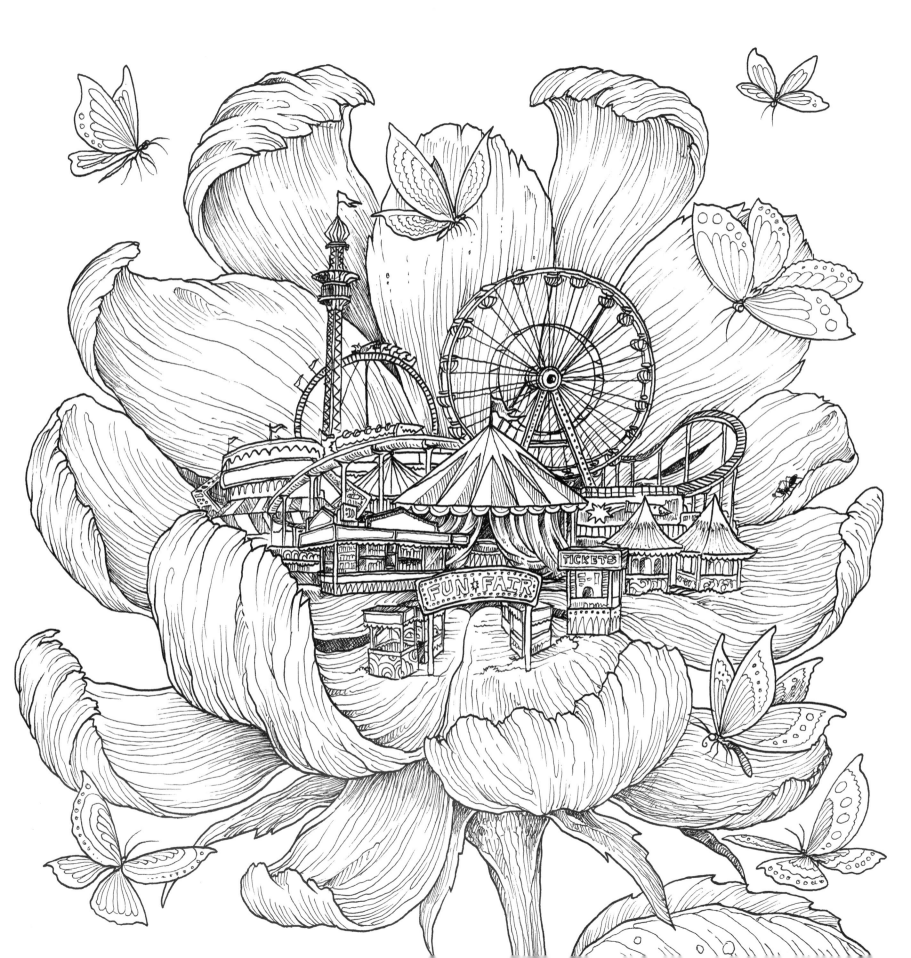

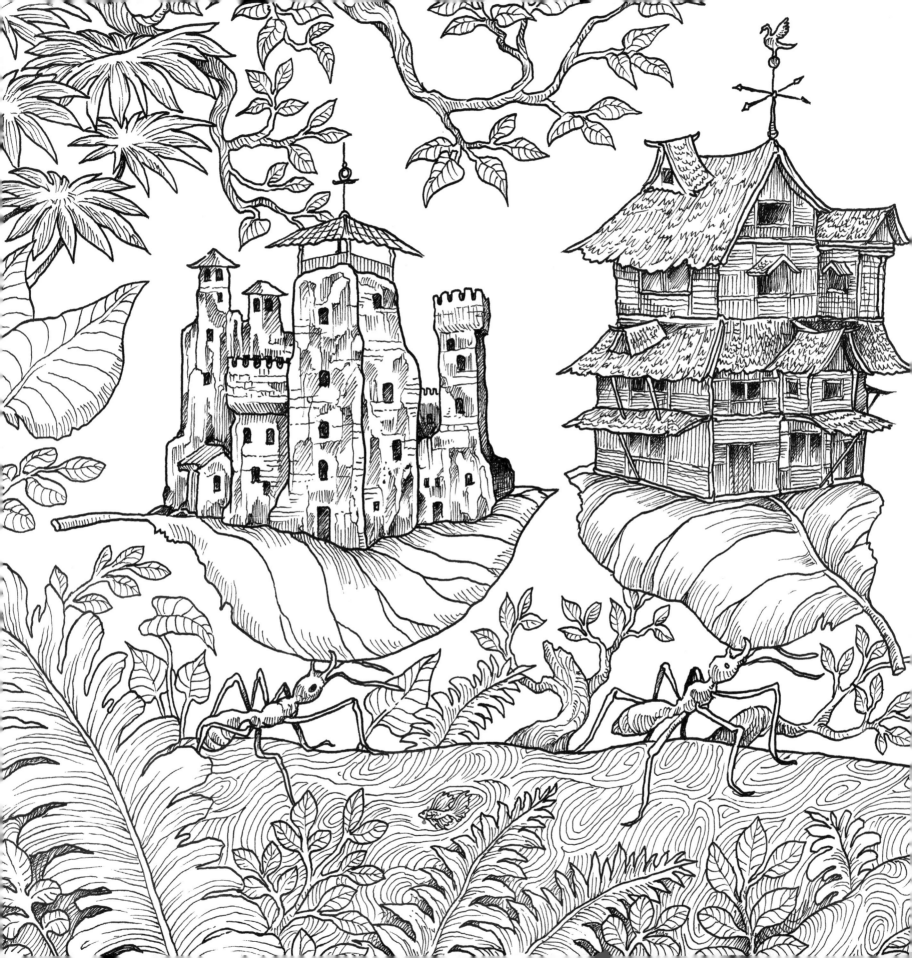

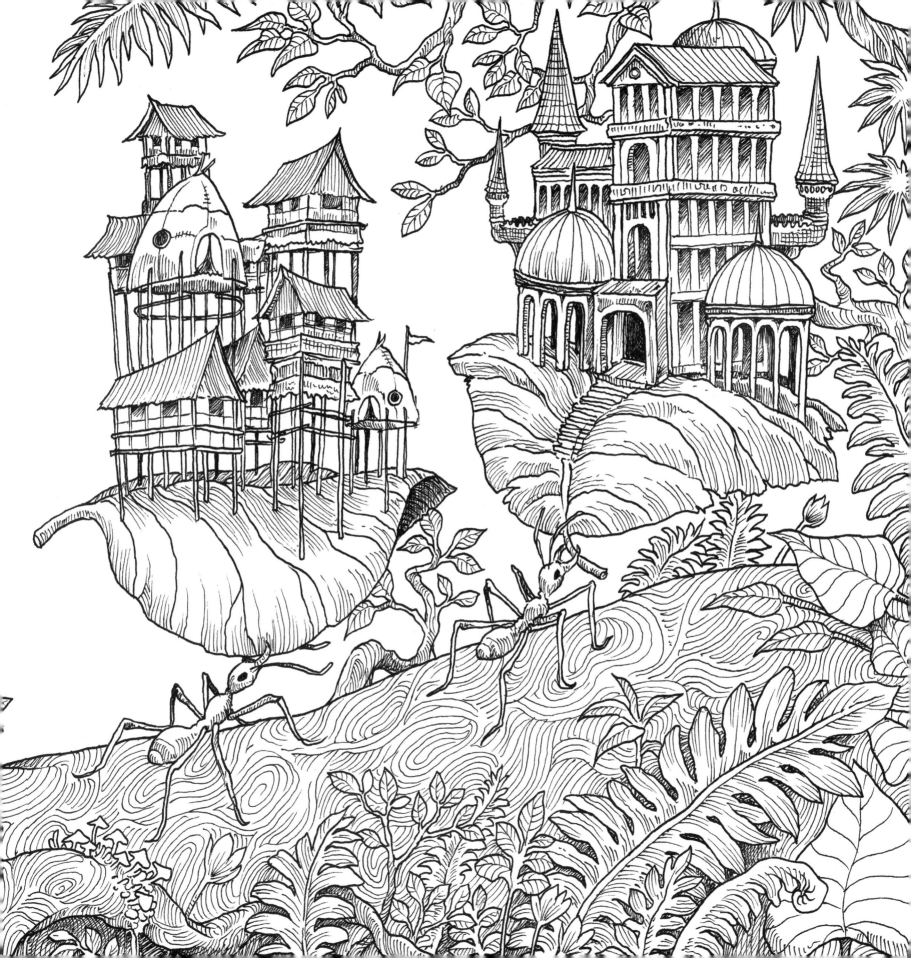

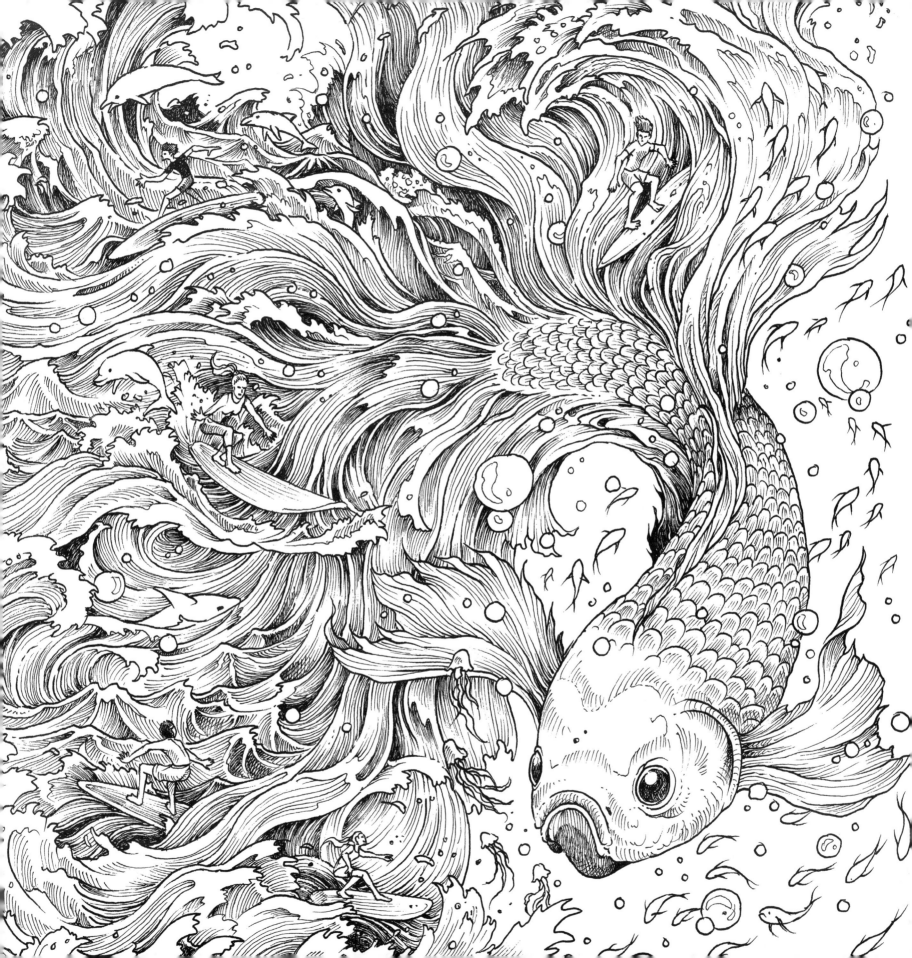

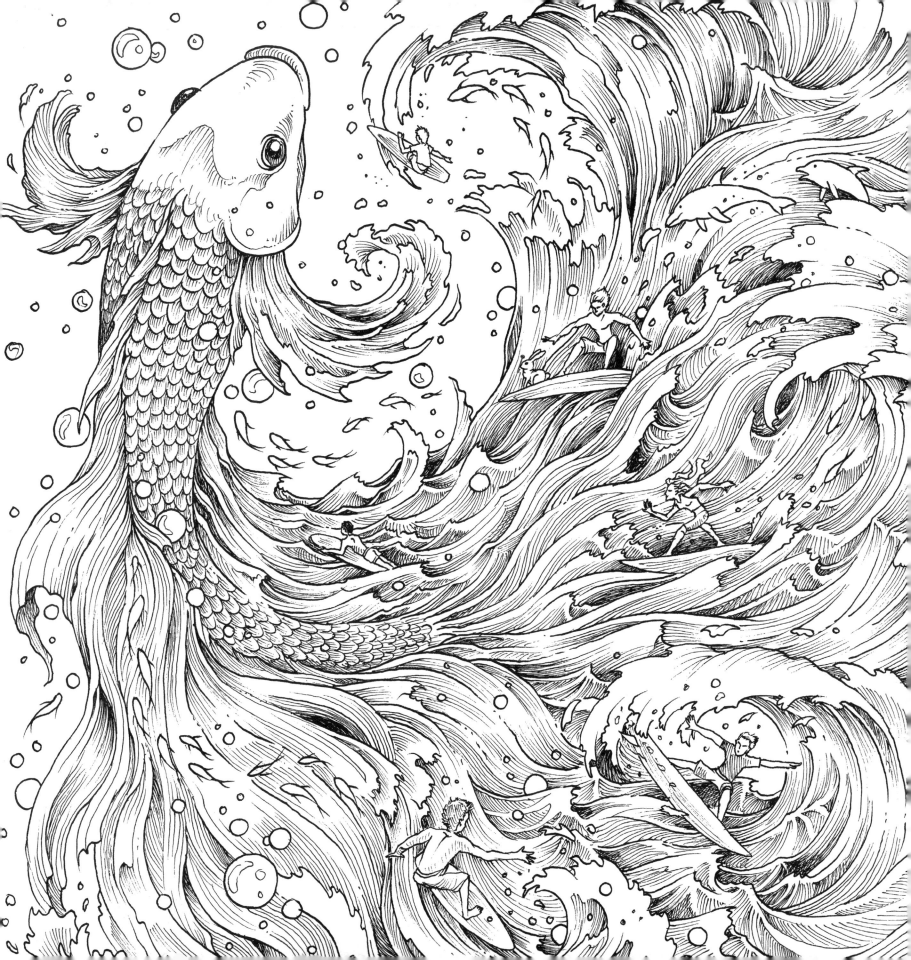

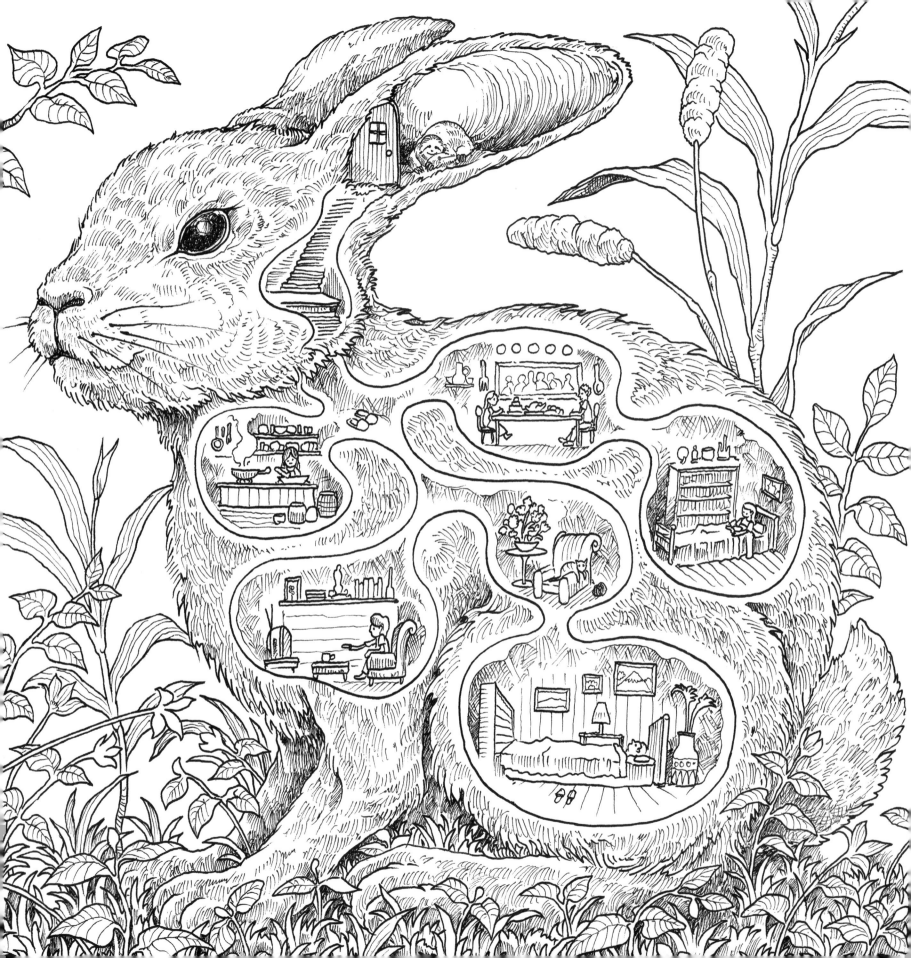

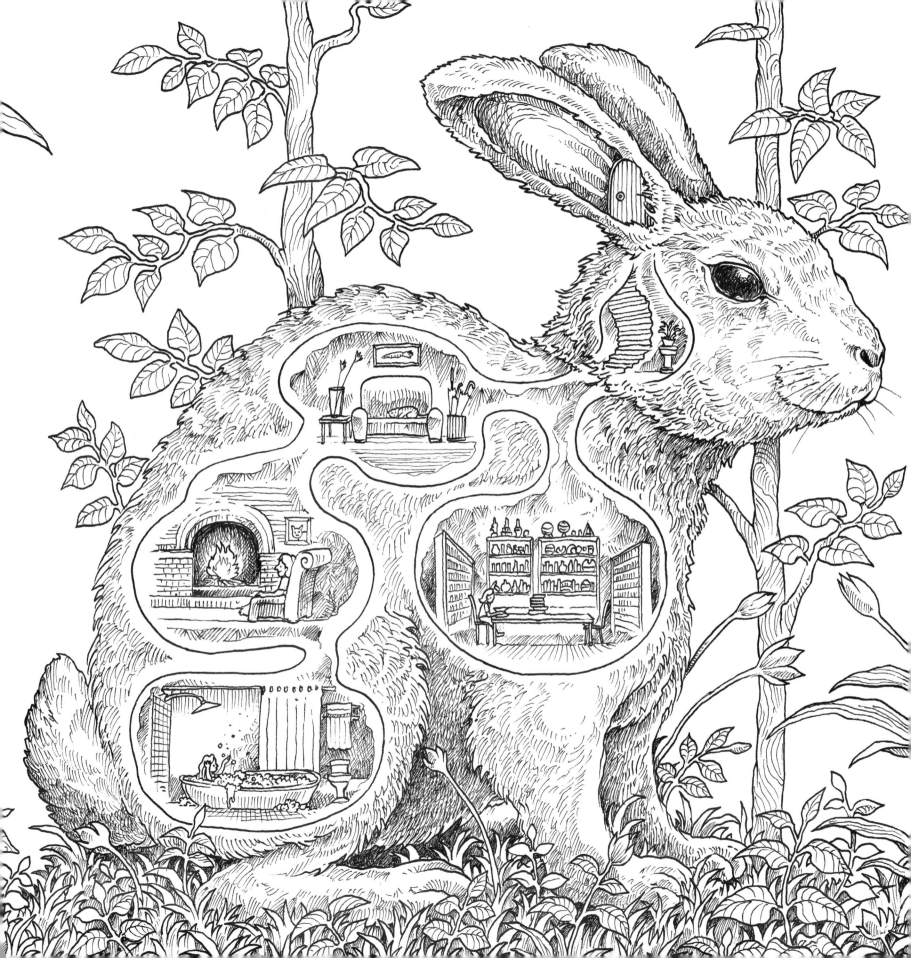

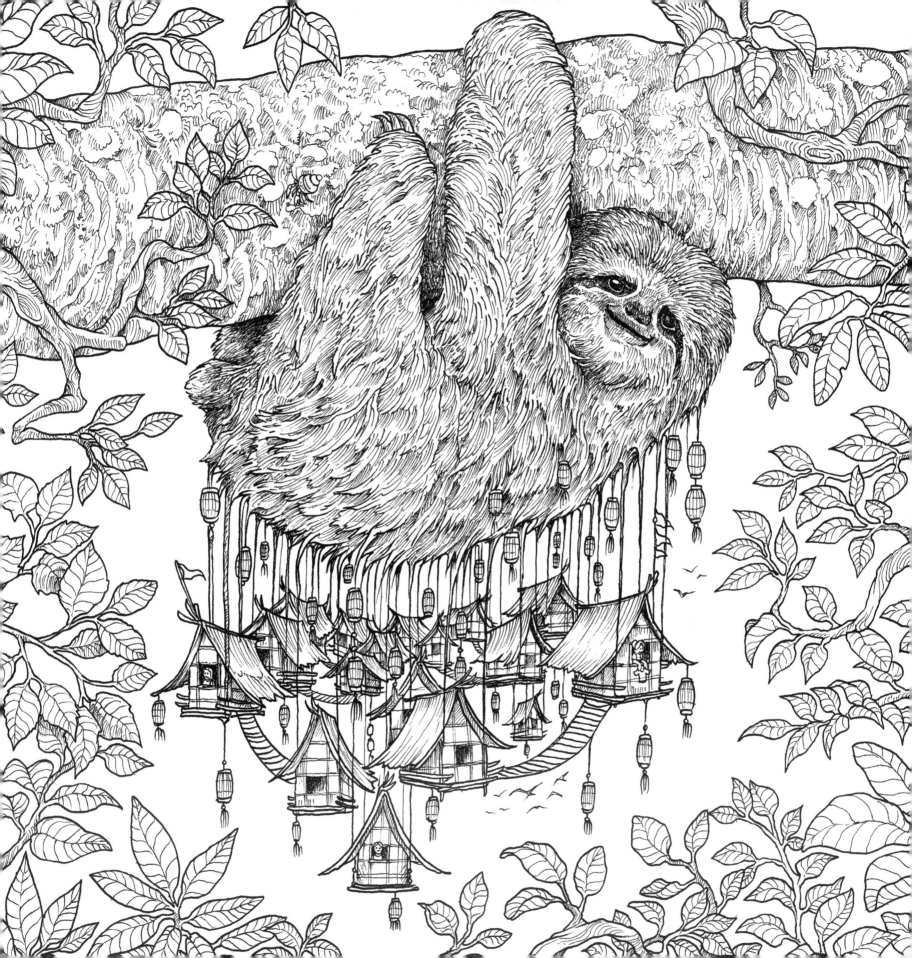

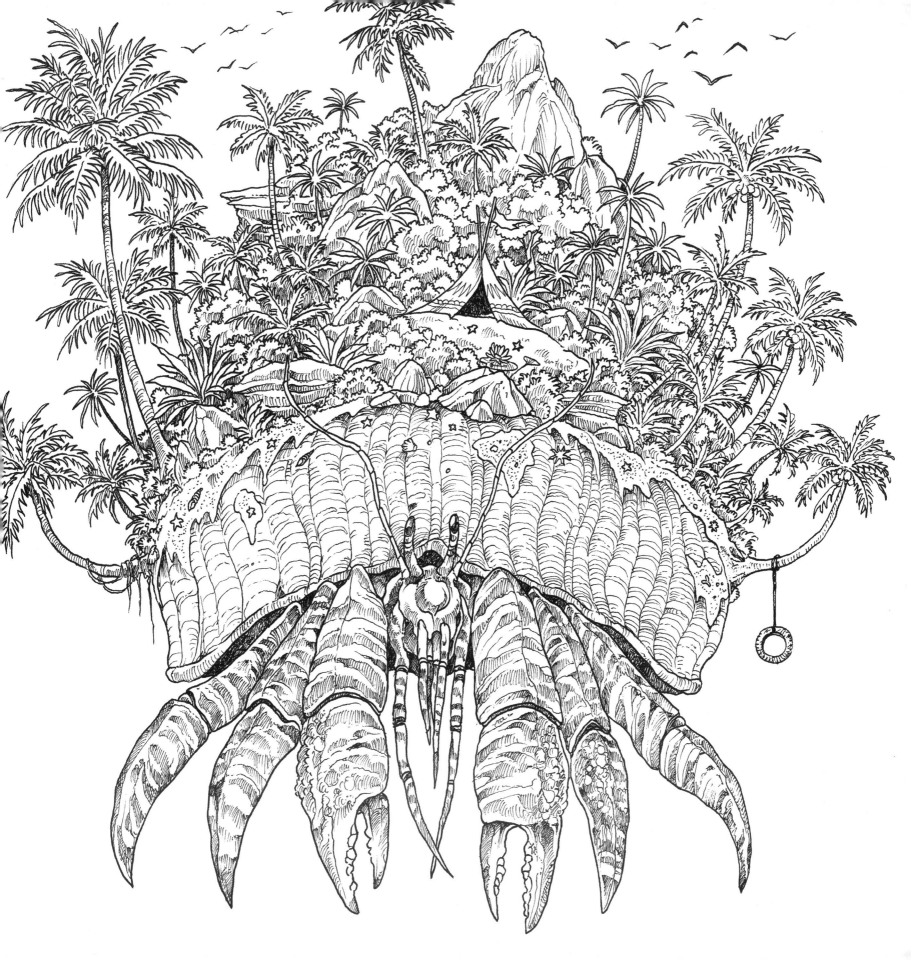

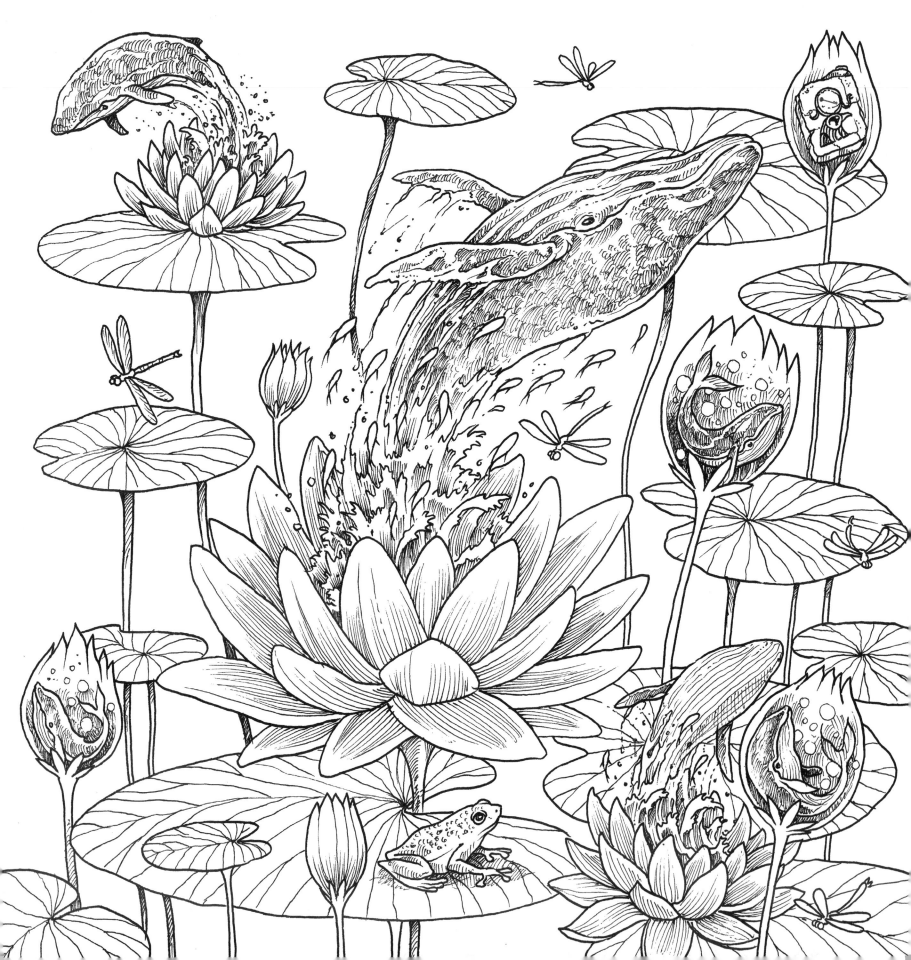

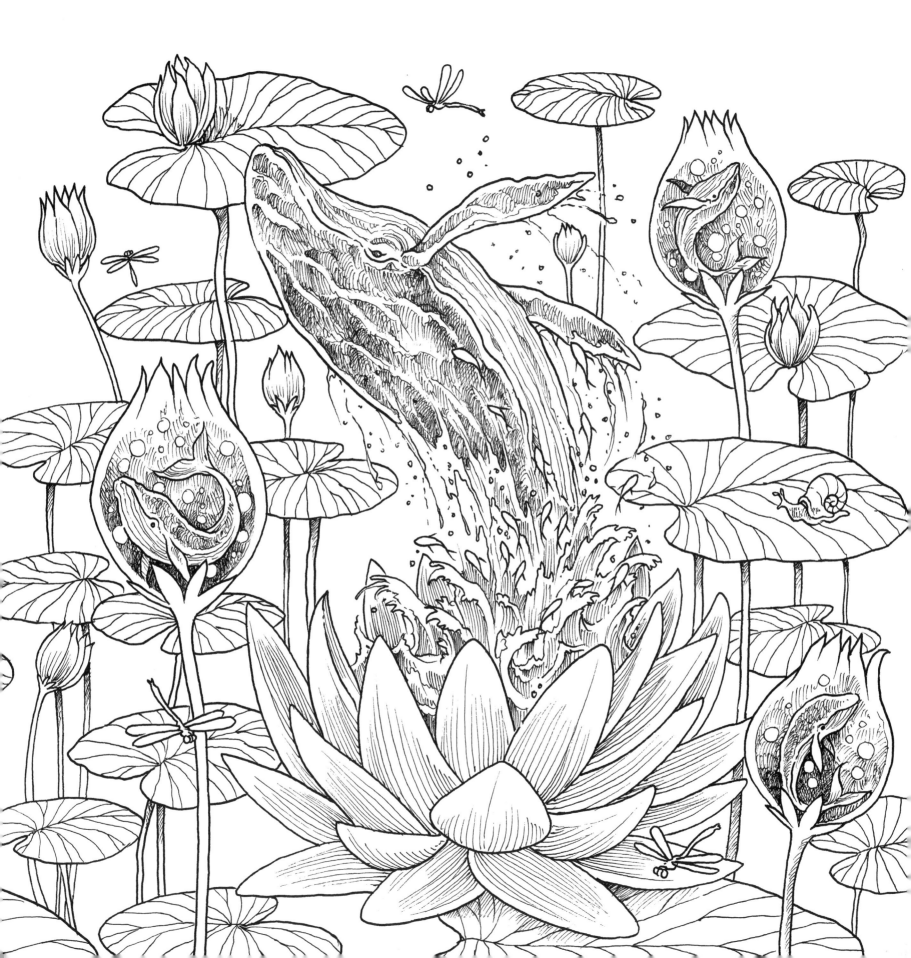

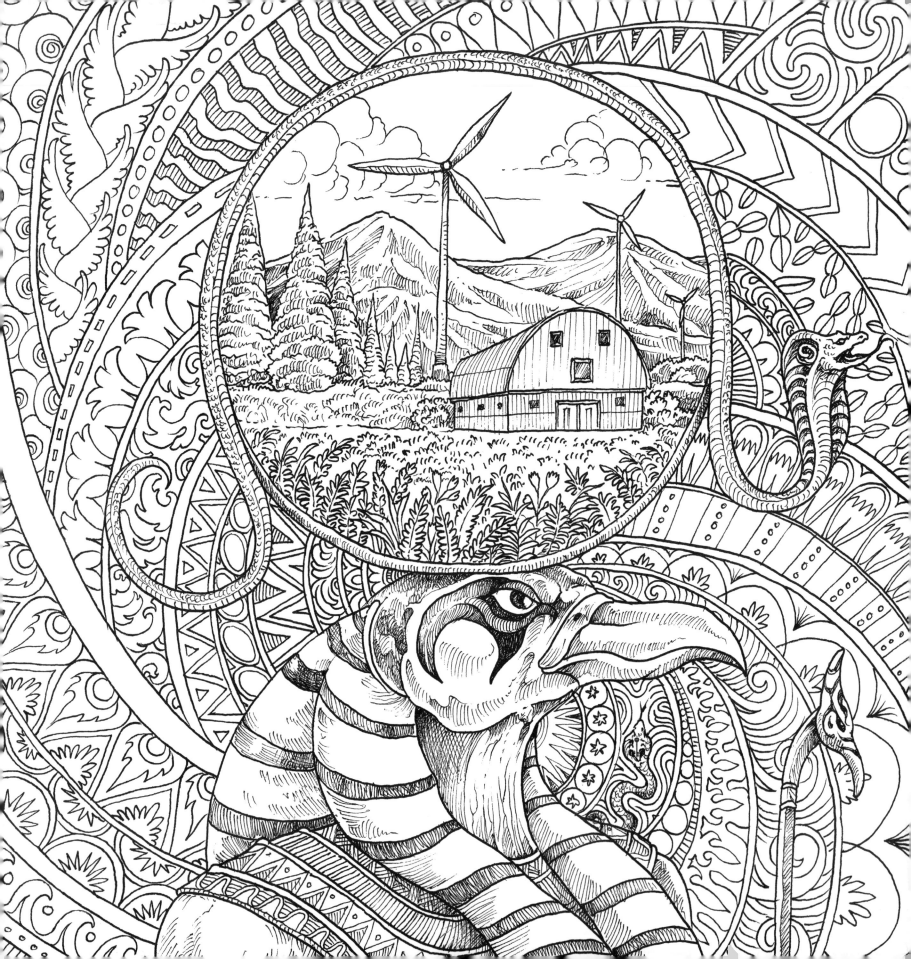

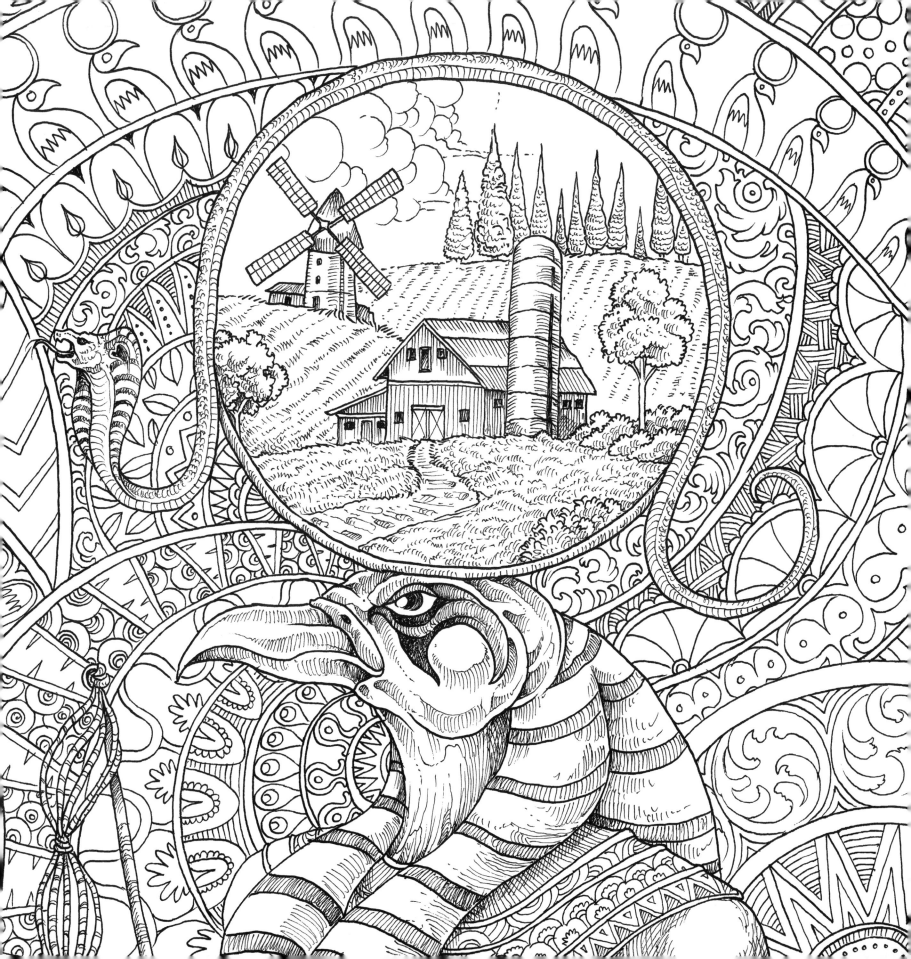

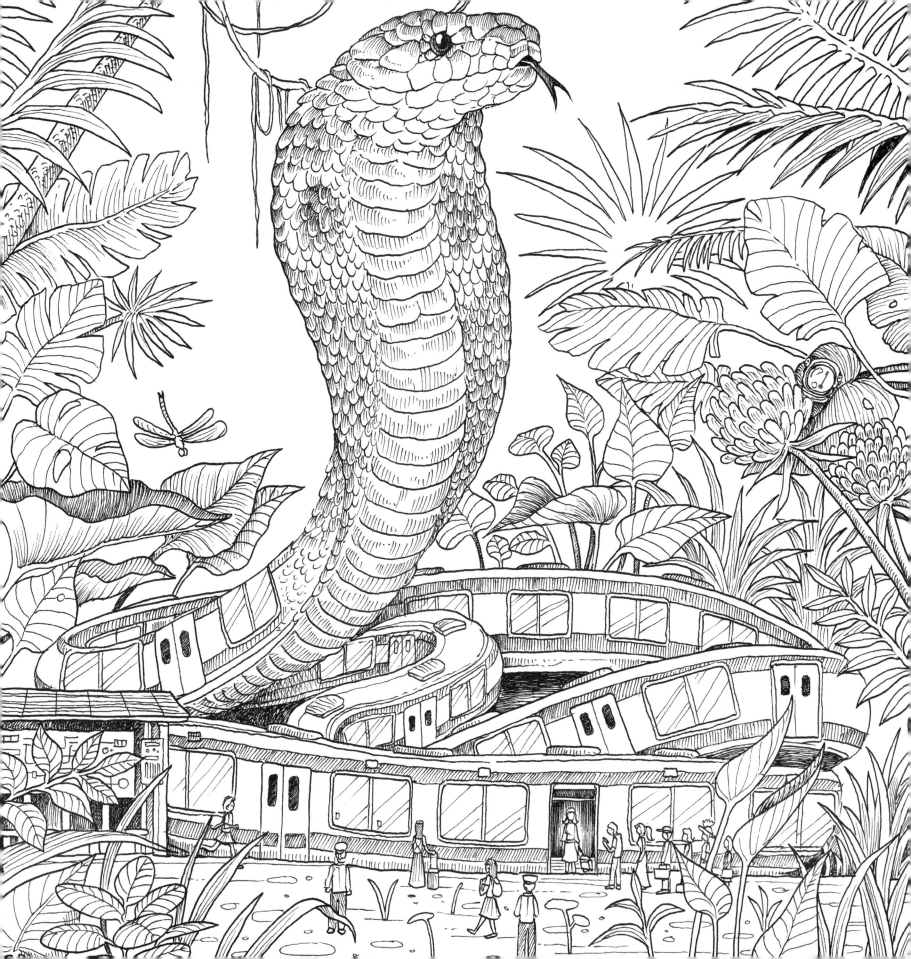

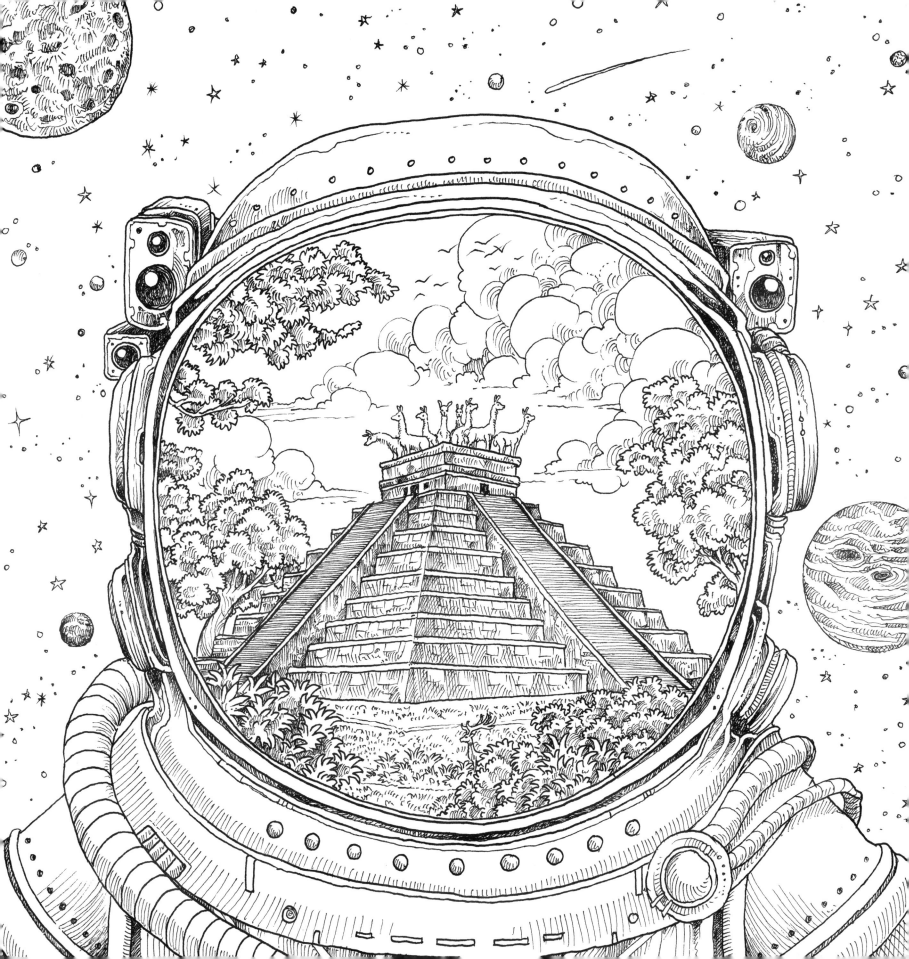

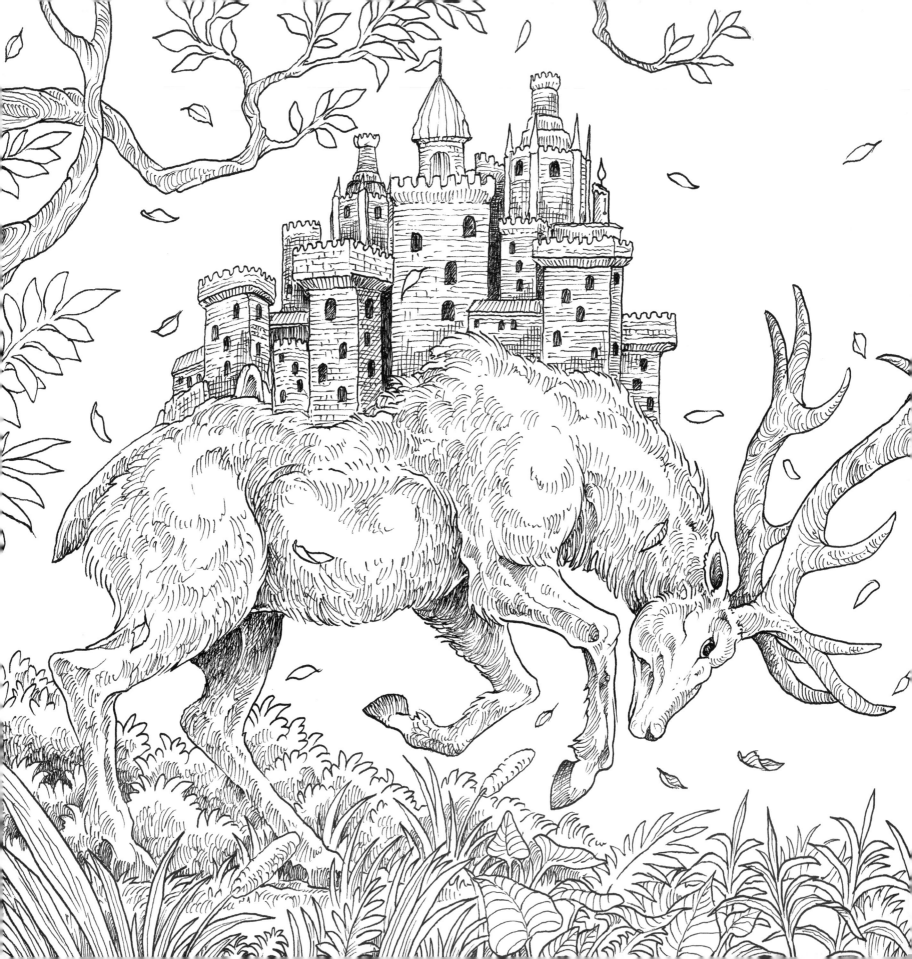

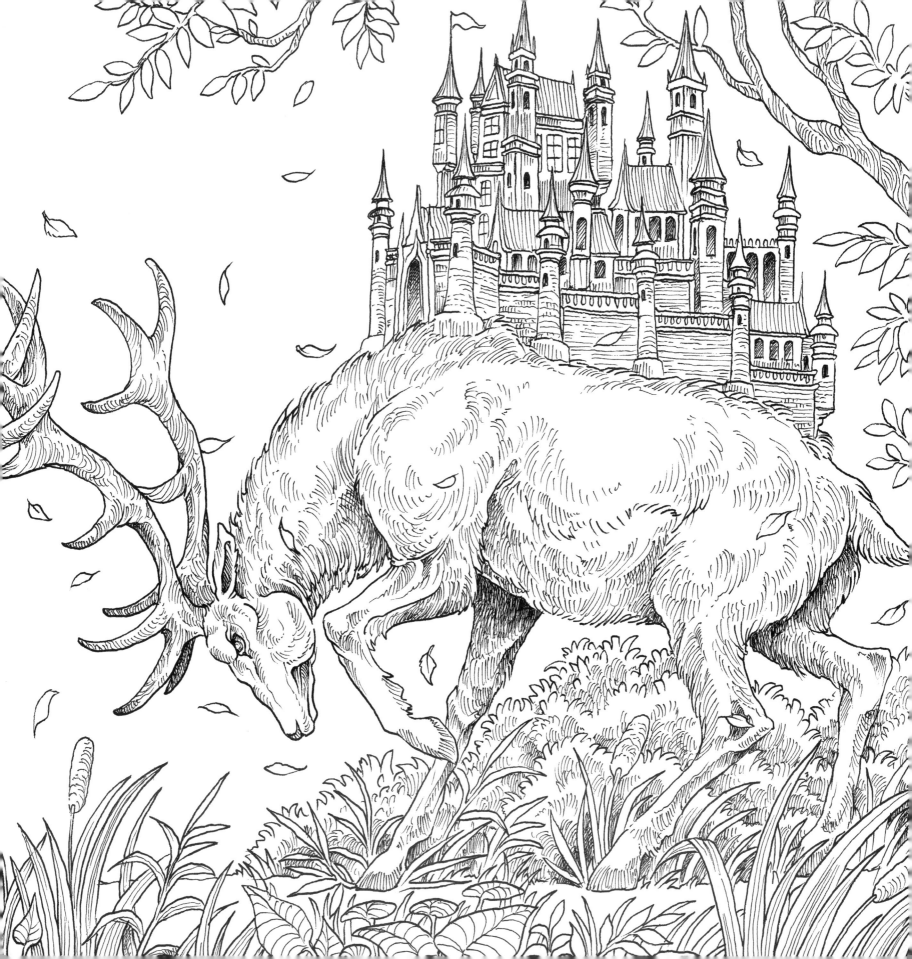

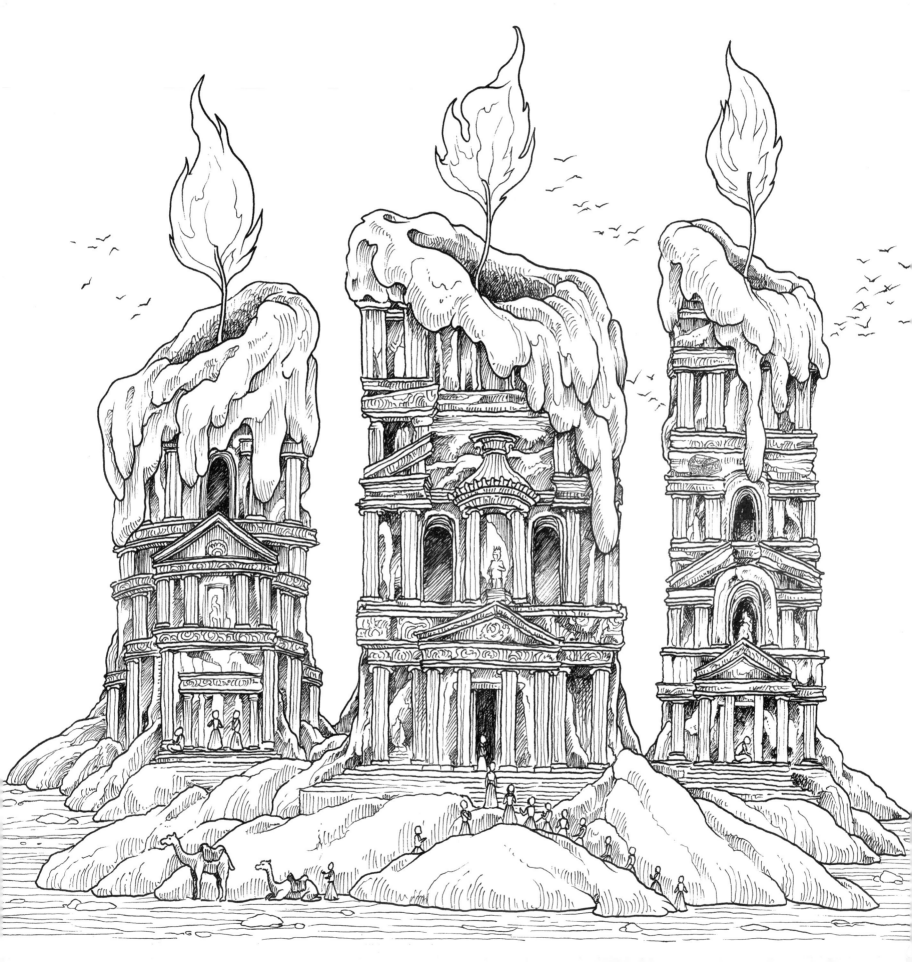

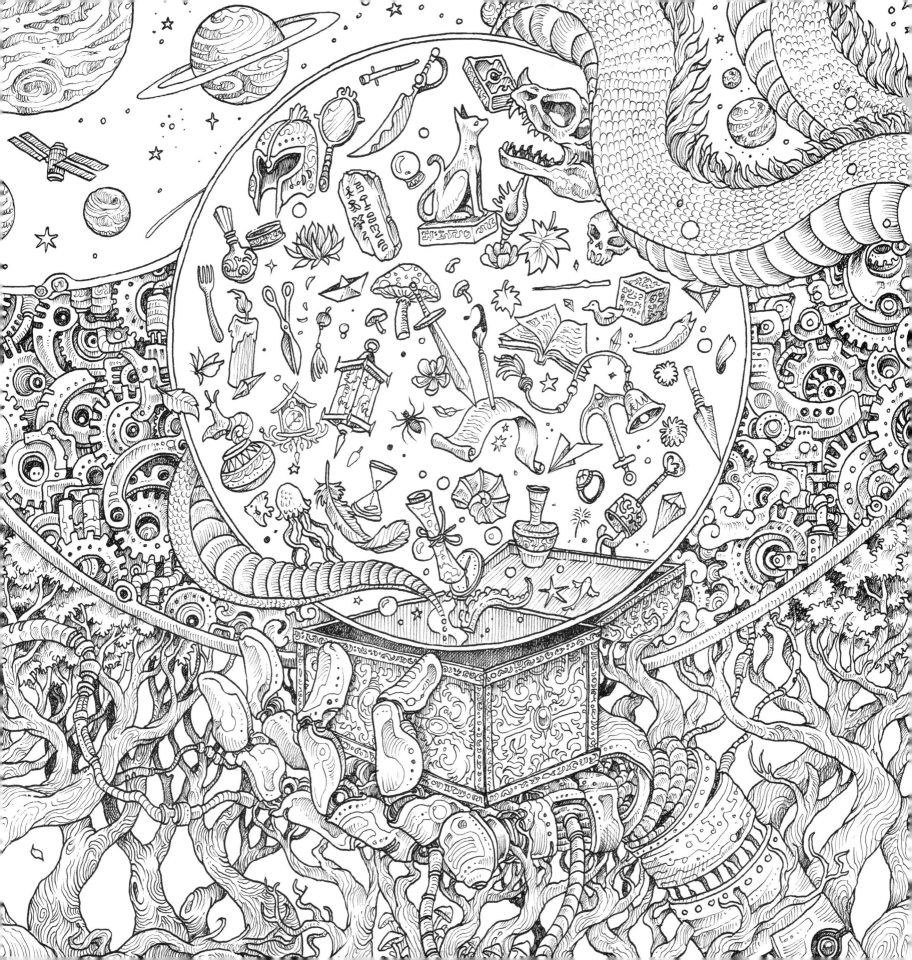

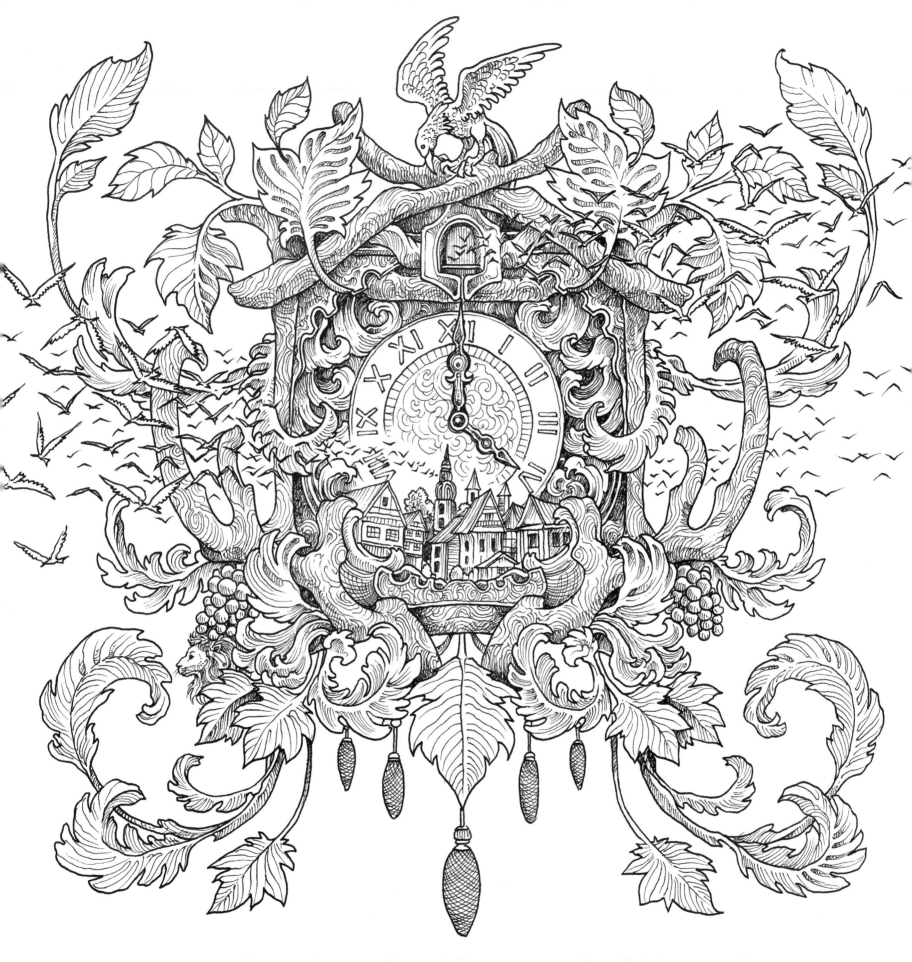

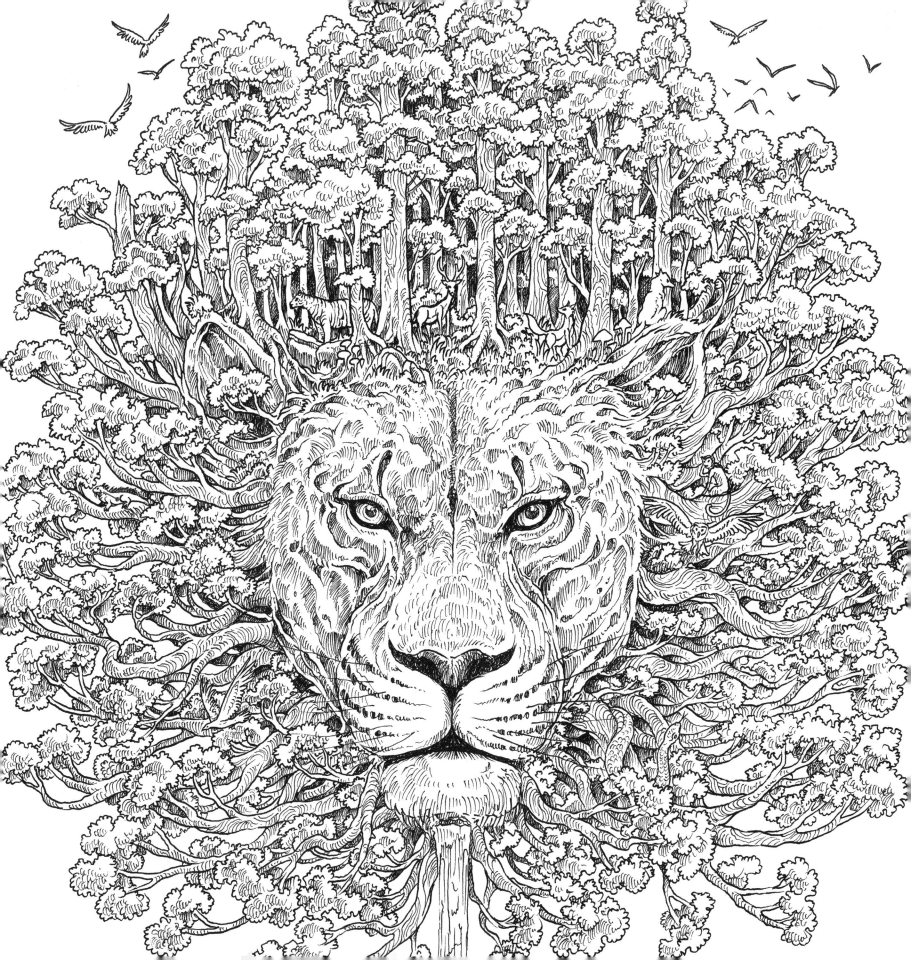

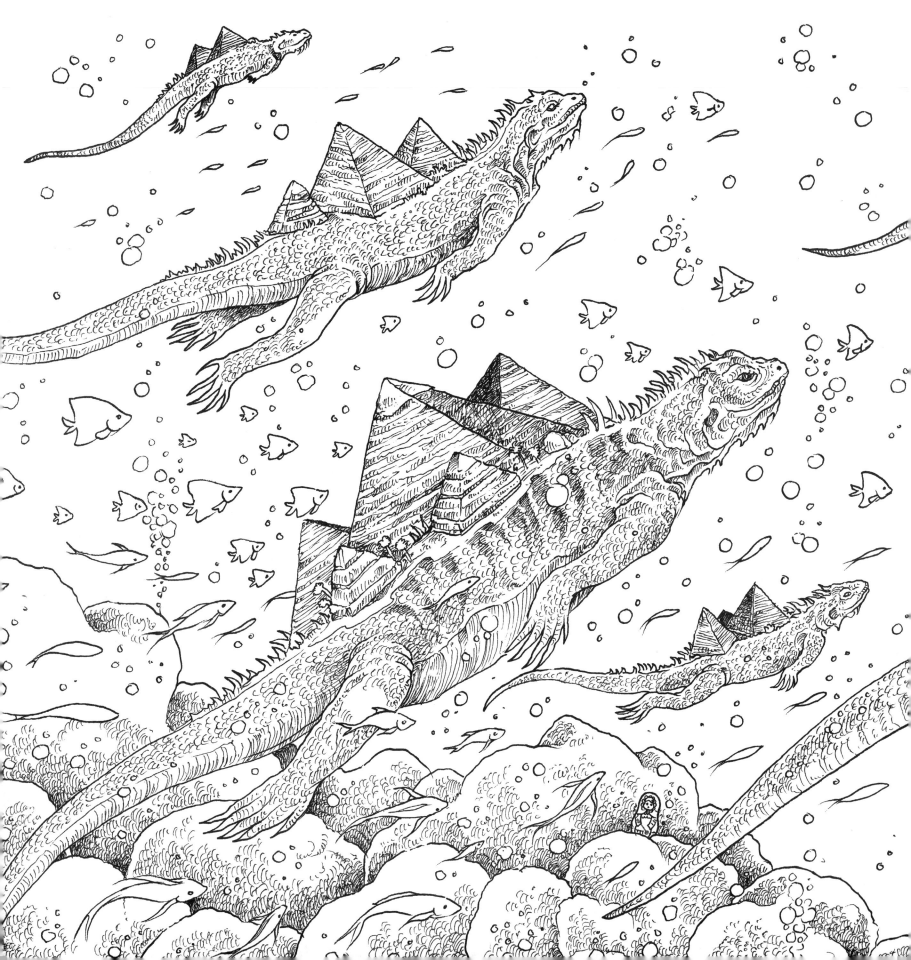

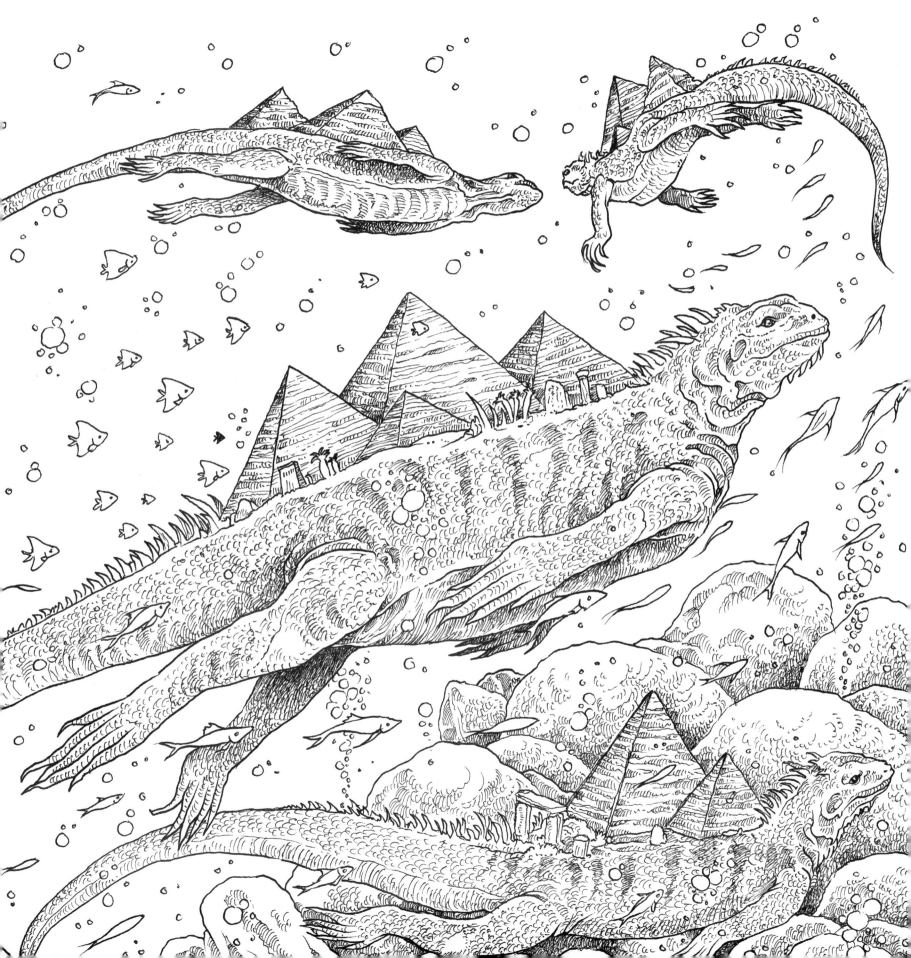

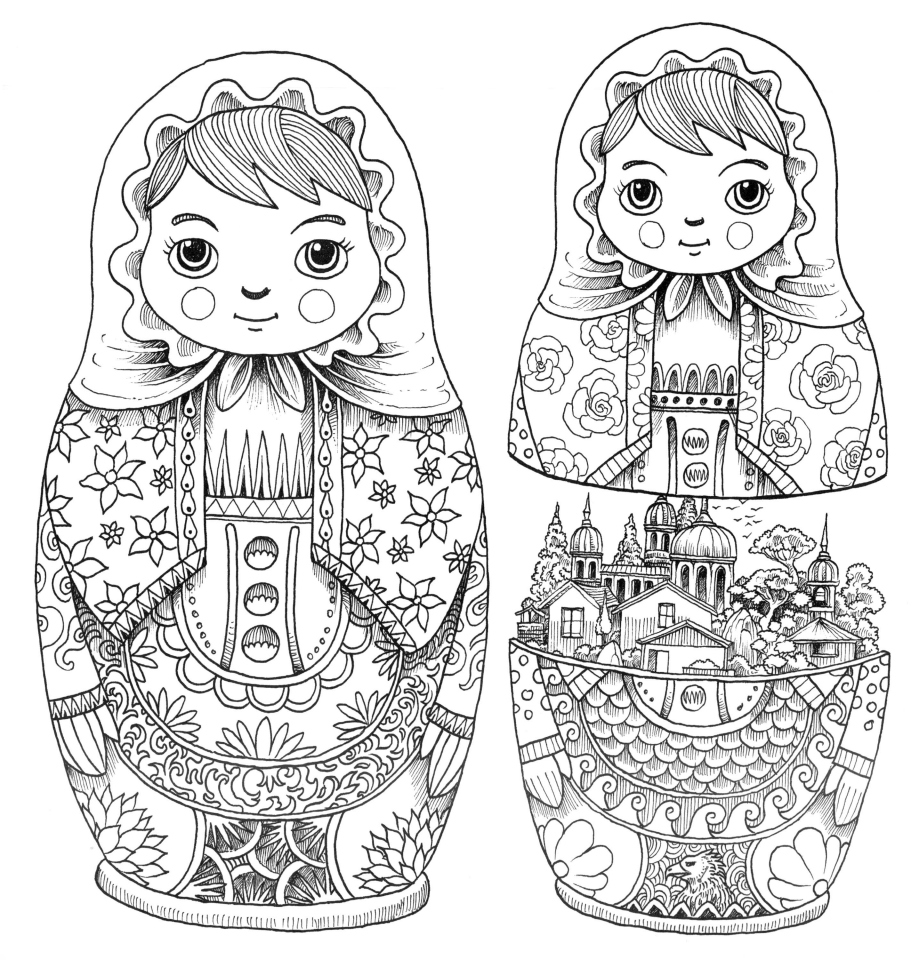

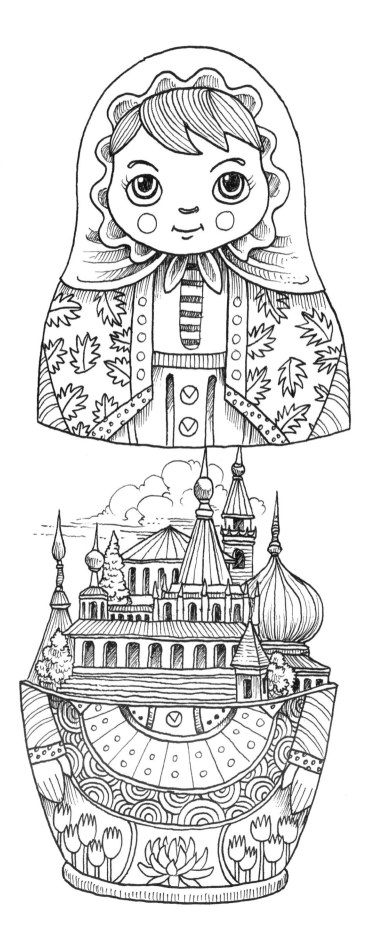
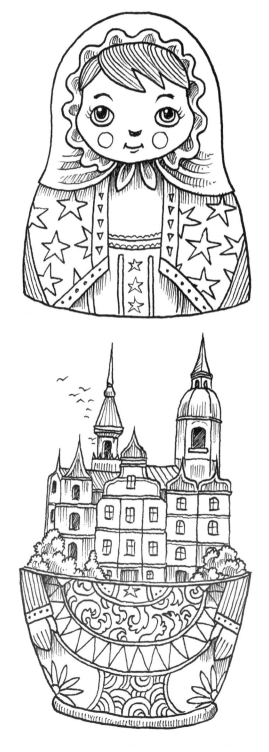
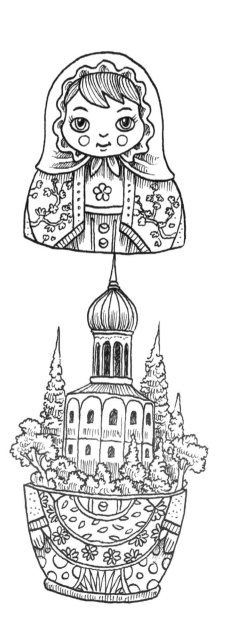

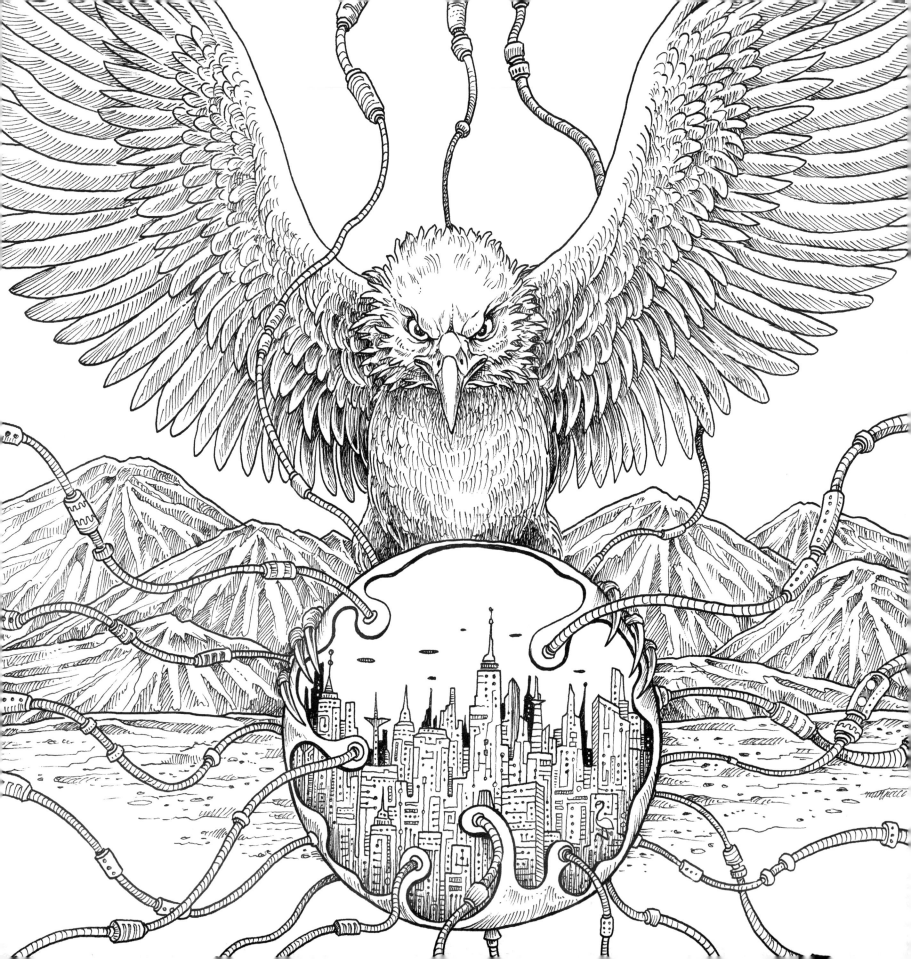

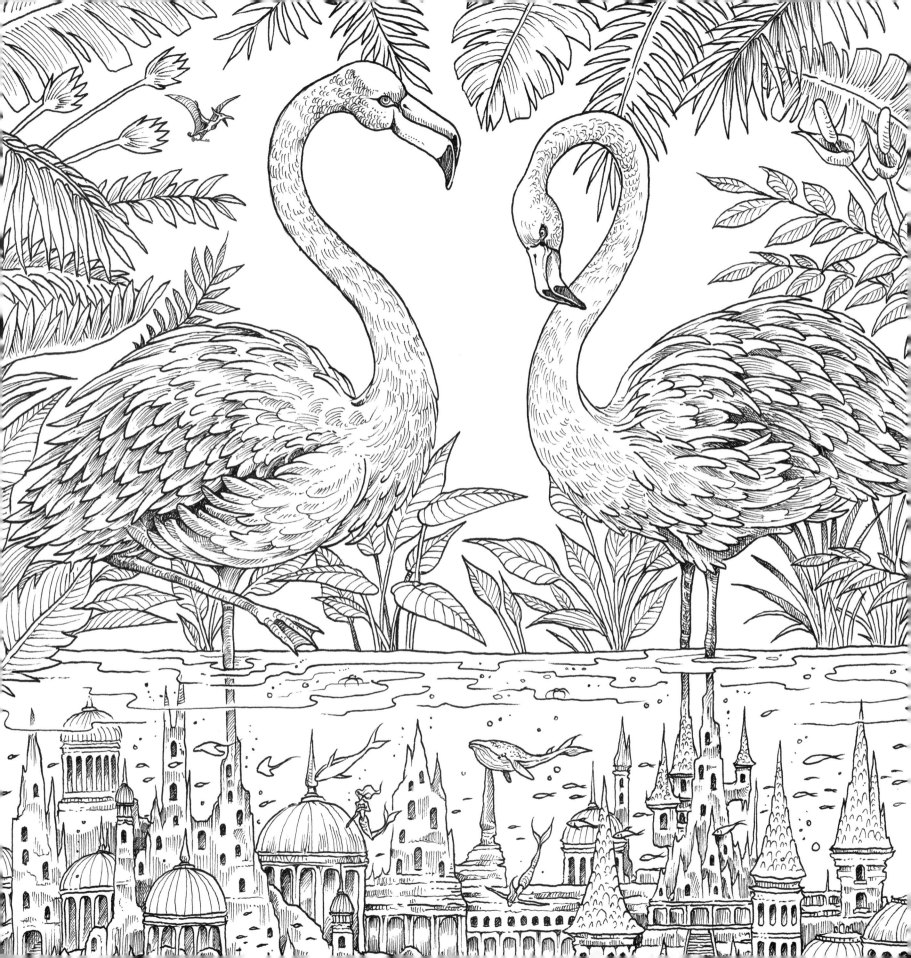

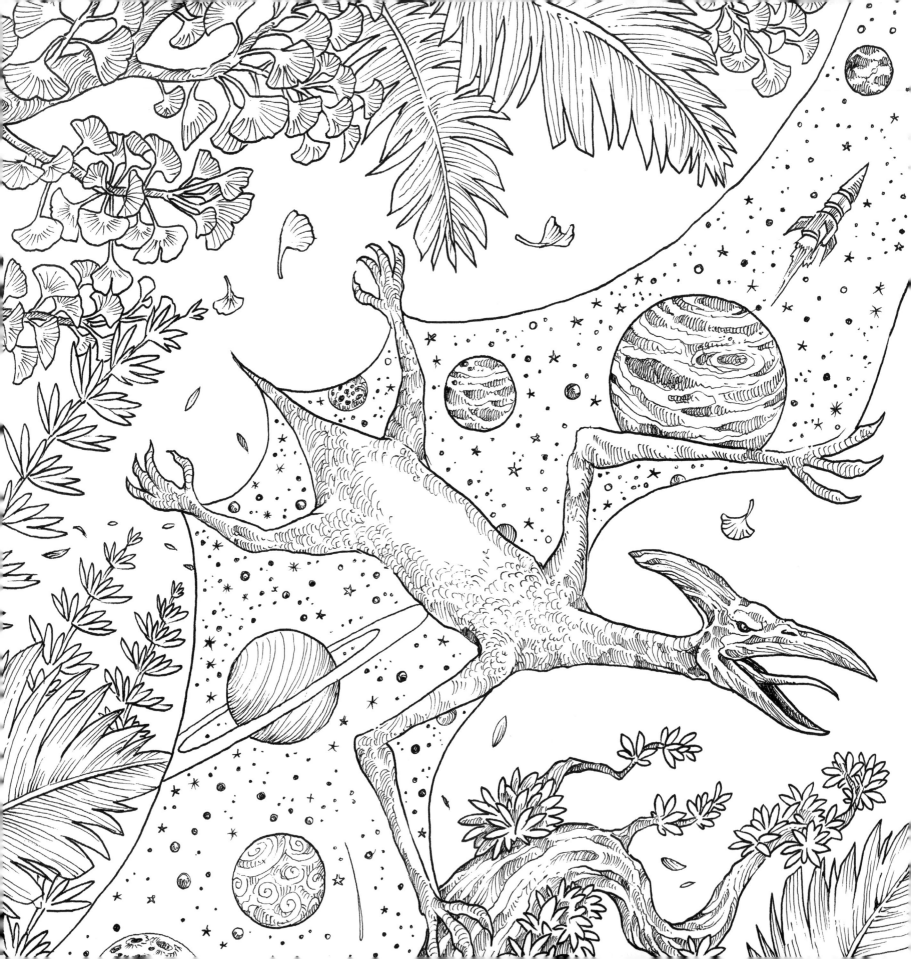

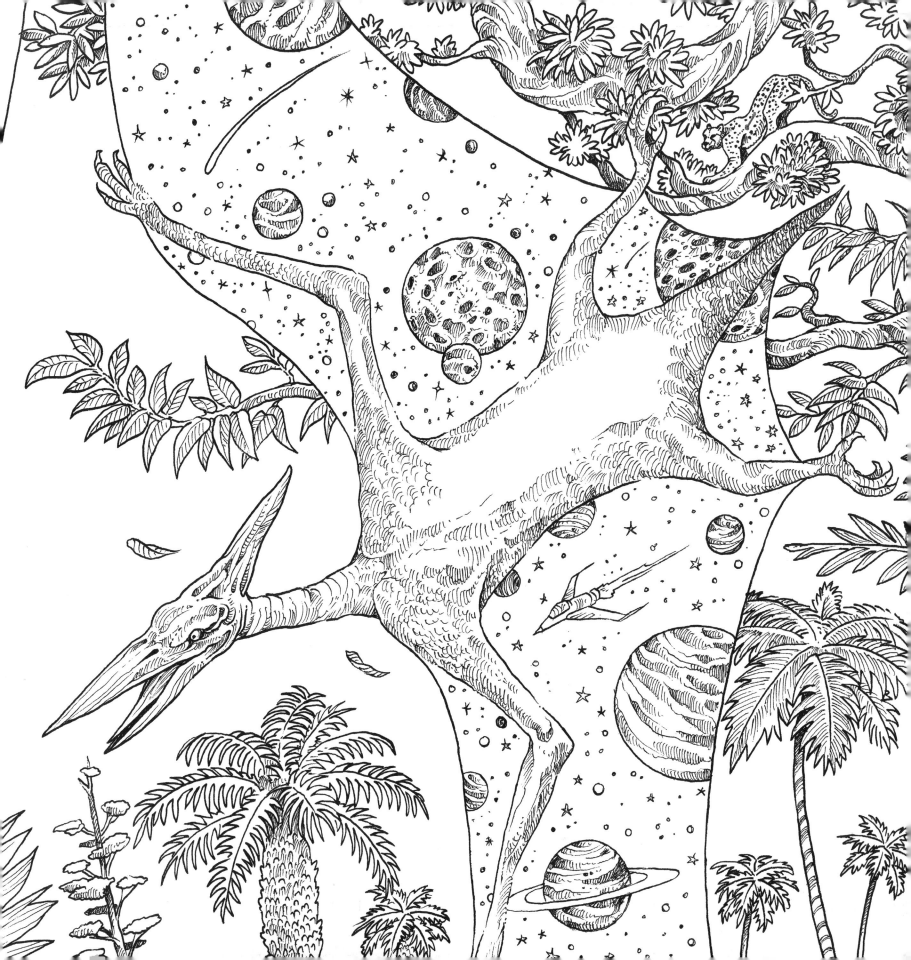

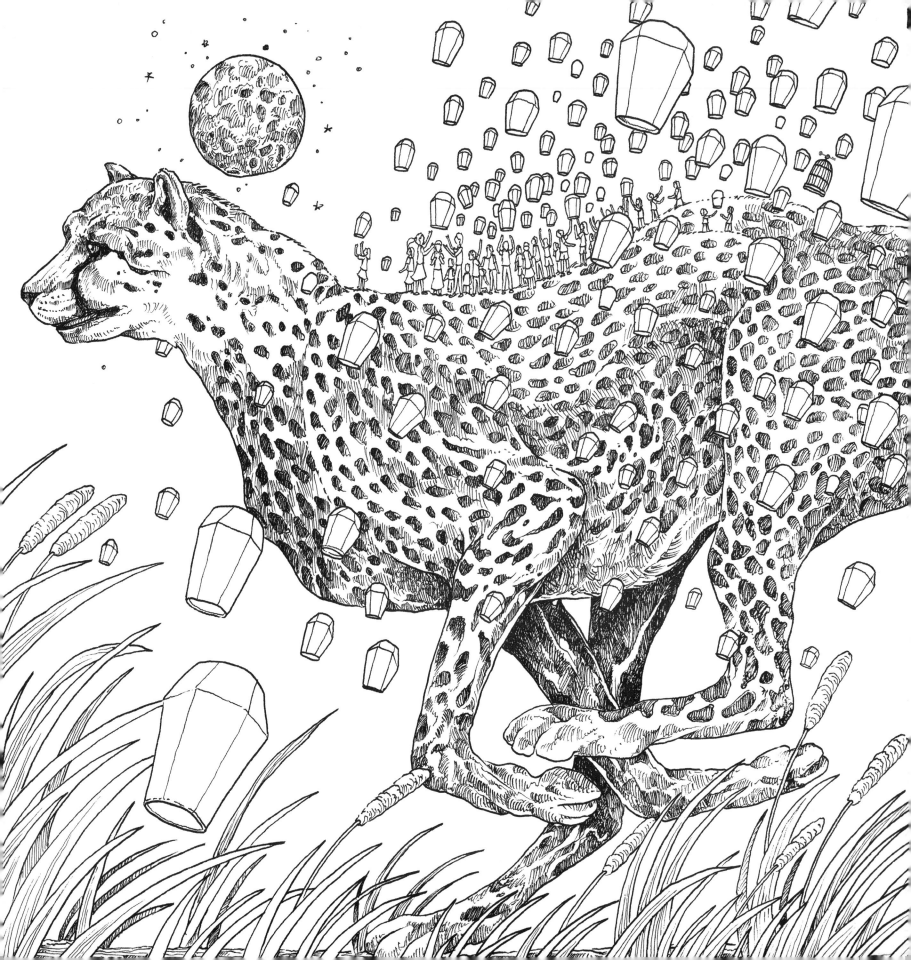

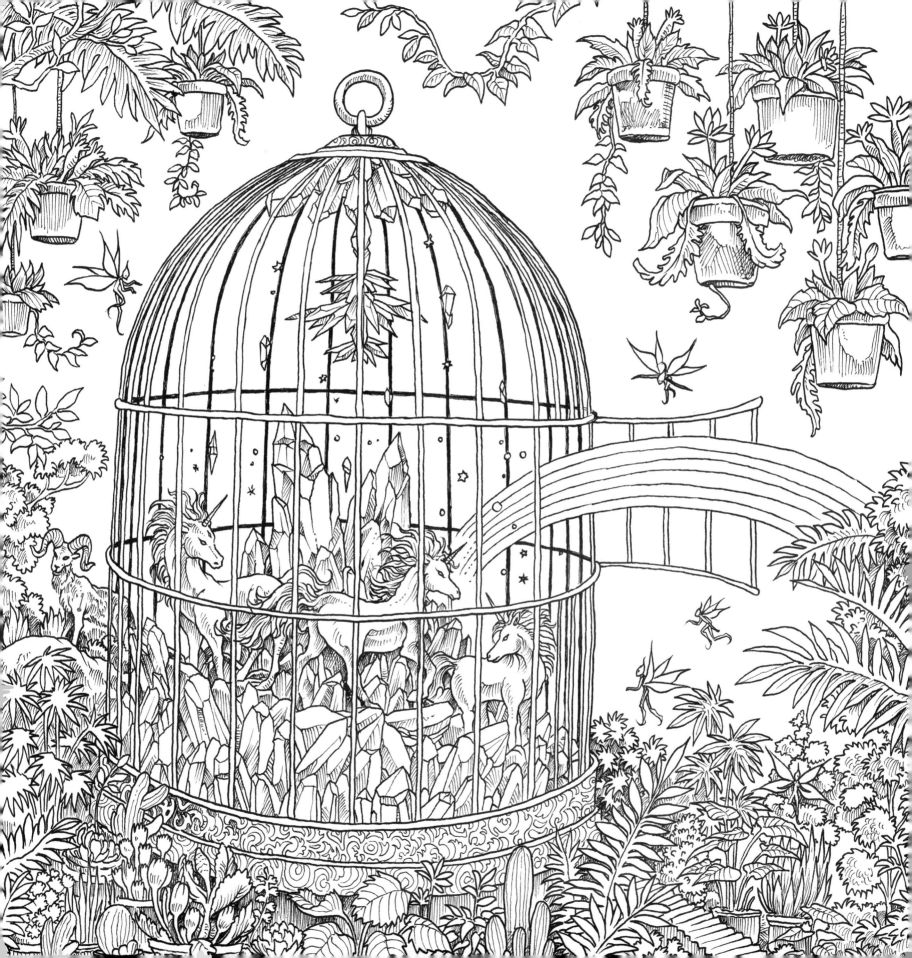

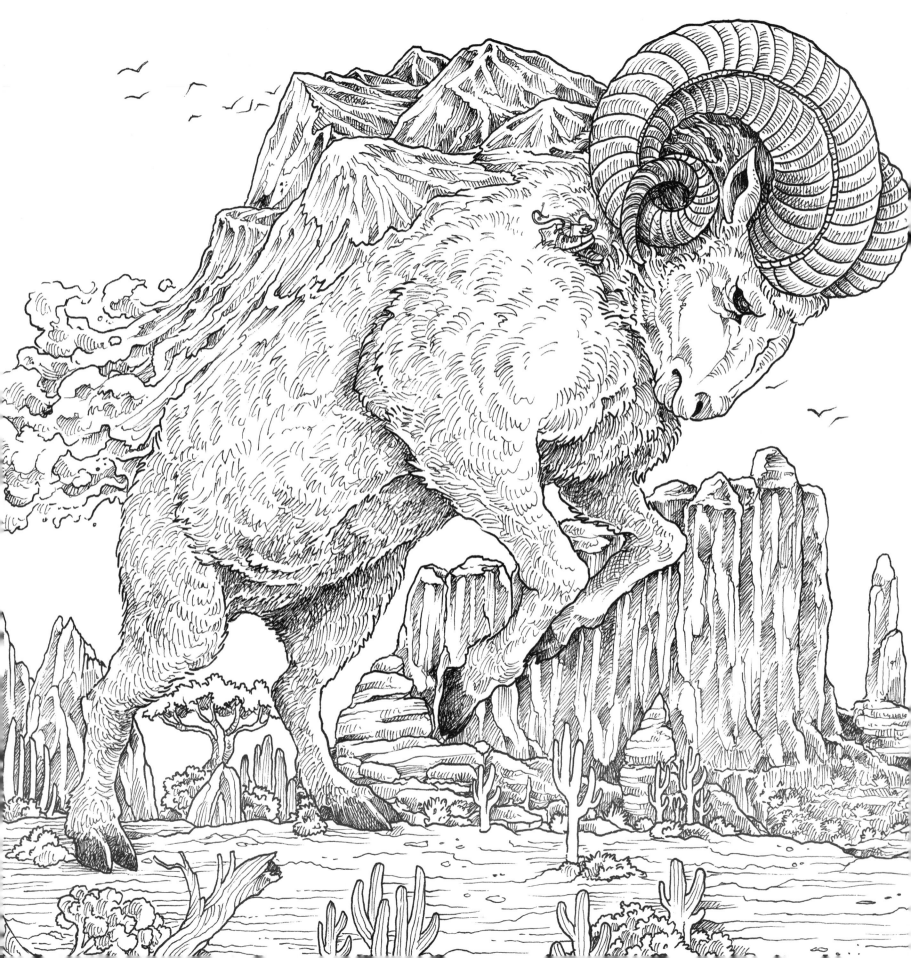

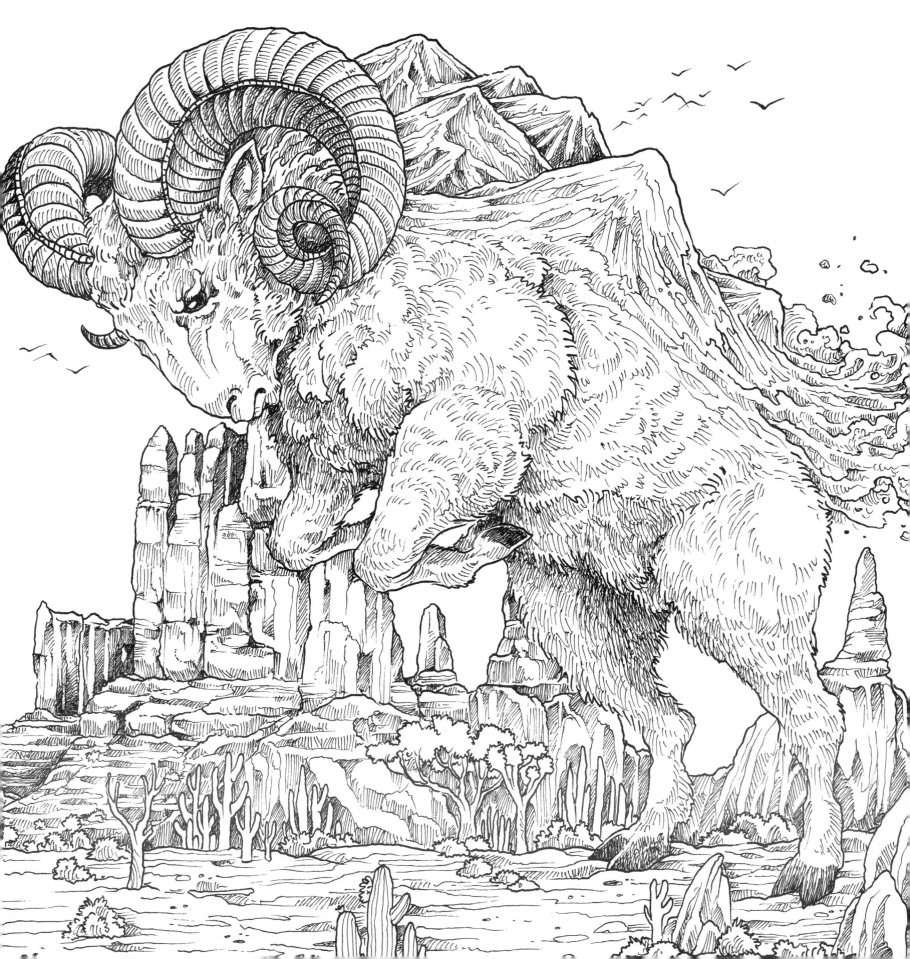

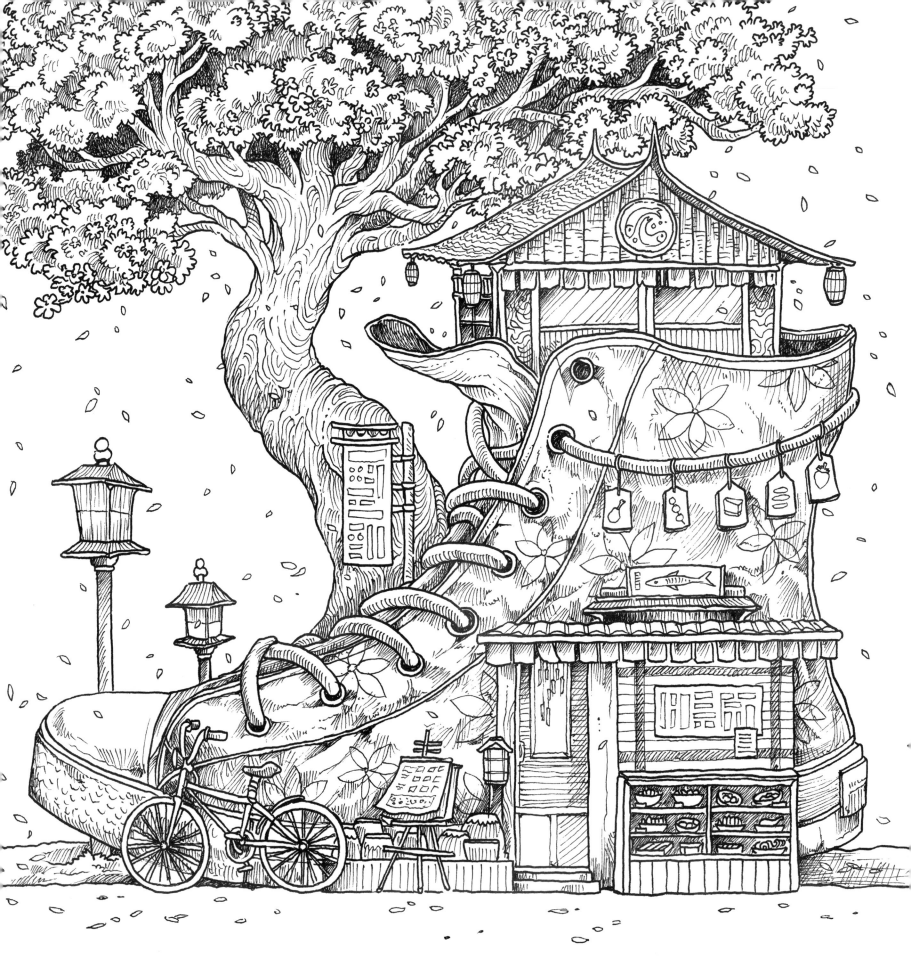

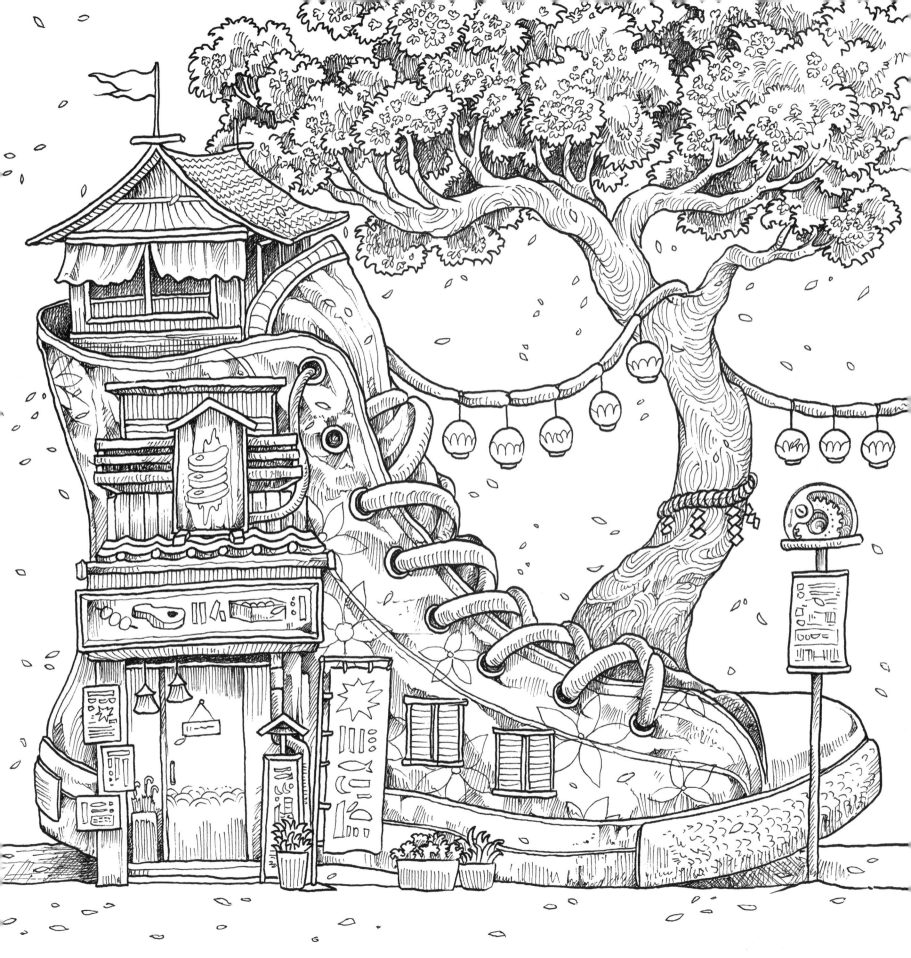

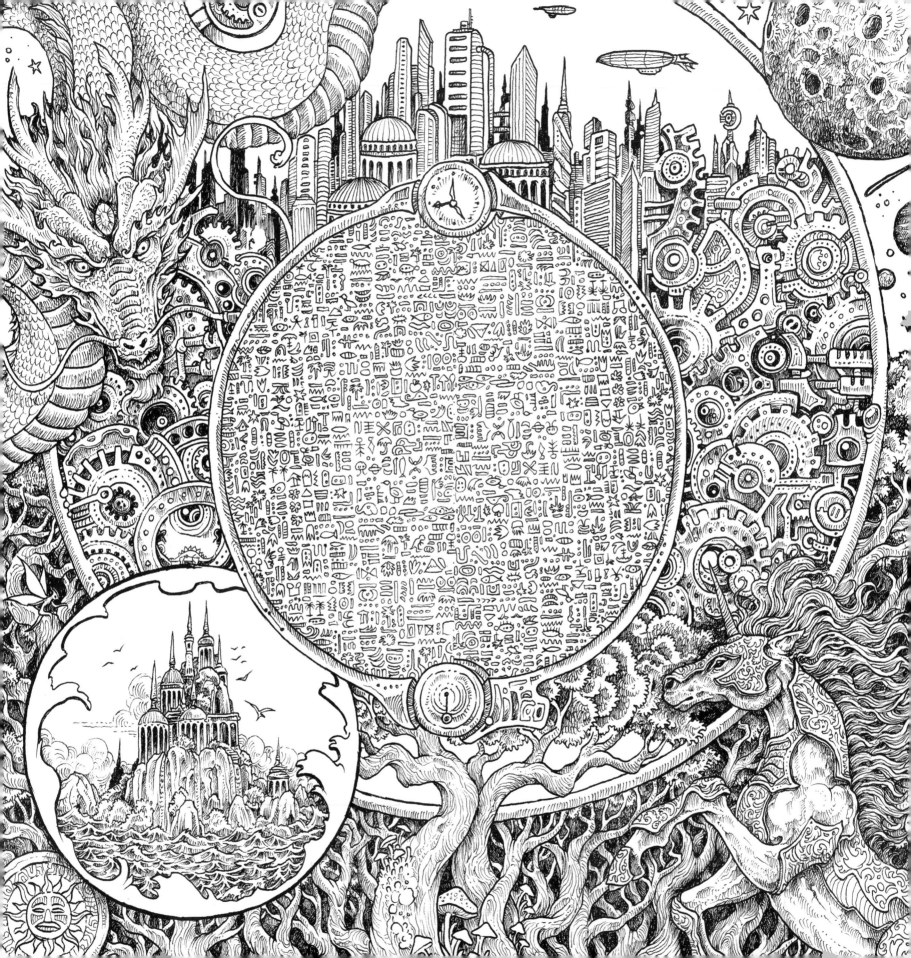

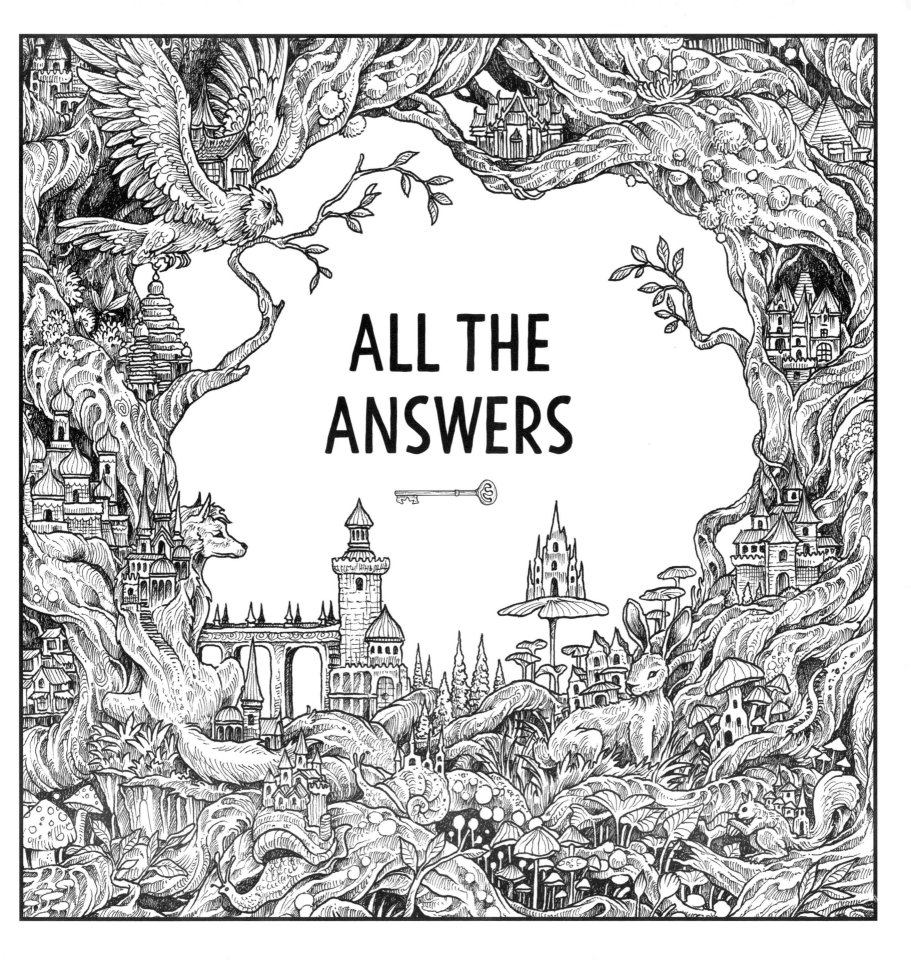

ALL THE
ANSWERS

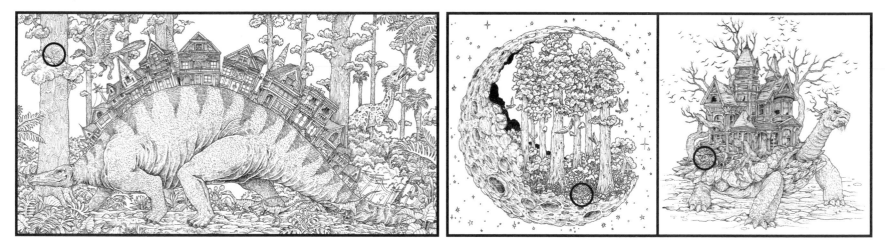

A moon

A tortoise

A skull

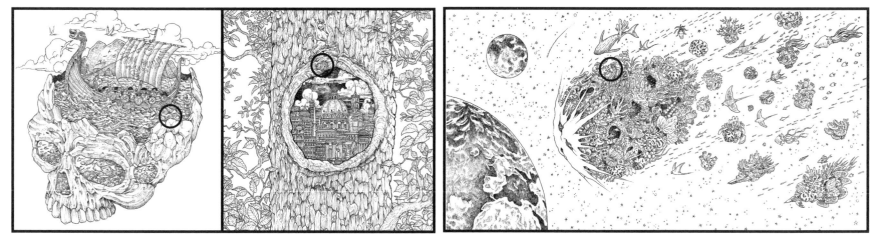

A leaf

An asteroid

A sea monster

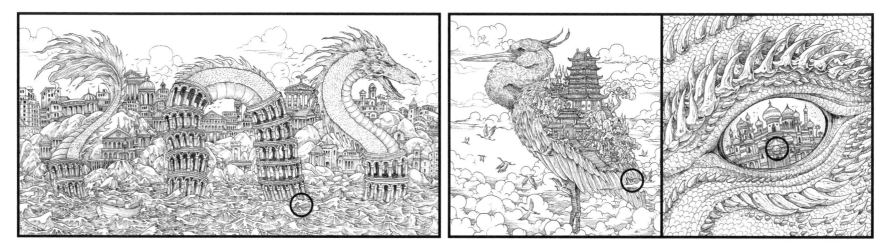

A crane feather

A dragon's tail

A book

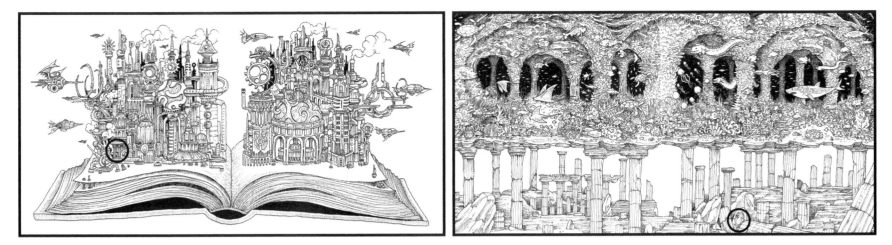

A Roman column

A pair of antlers

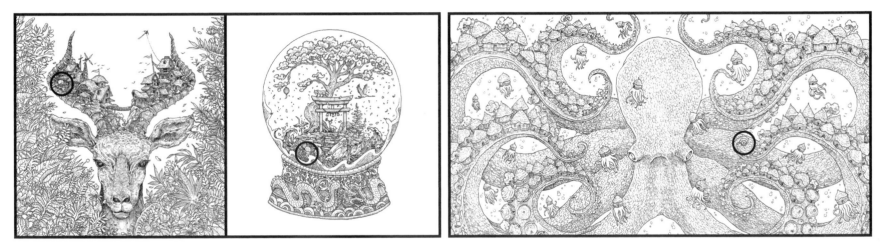

A snow globe

An octopus

A compass

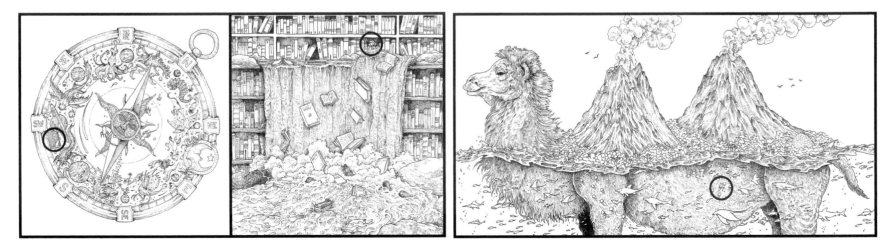

A bookcase

A volcanic rock

A shard of ice

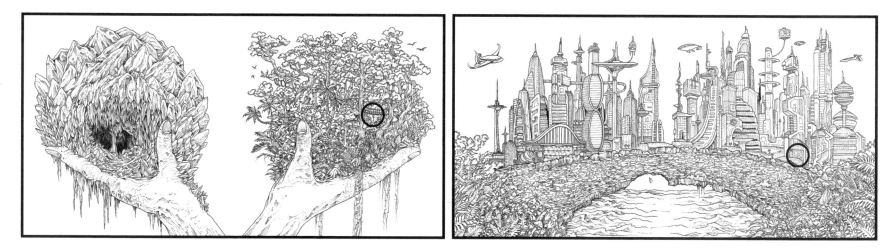

A bridge

A map

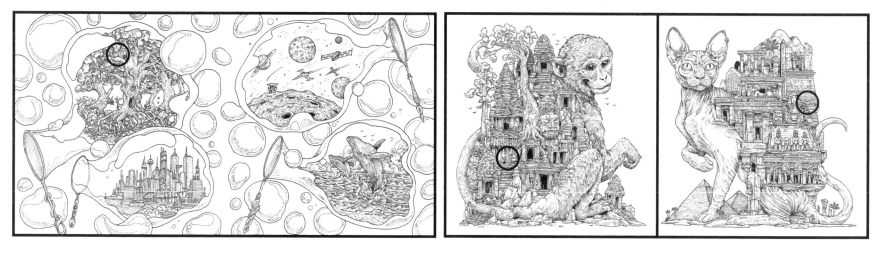

A monkey

A cat

An apple

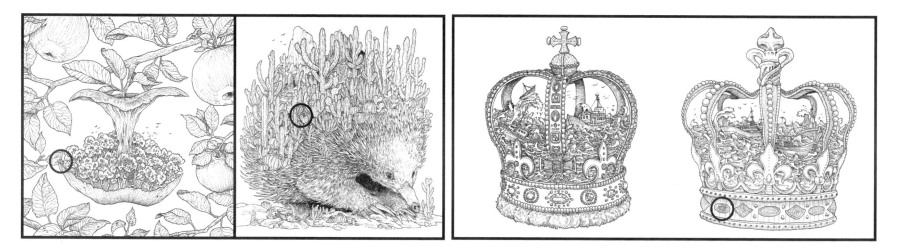

An echidna

A crown

A dragon's egg

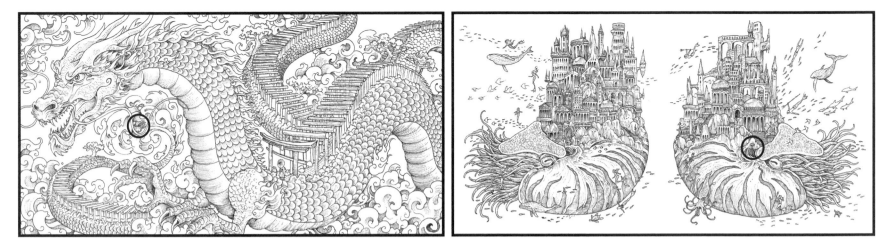

A nautilus

A toadstool

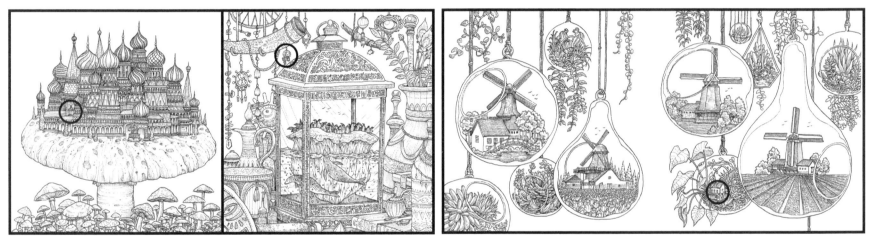

A lantern

A terrarium

A doll's house

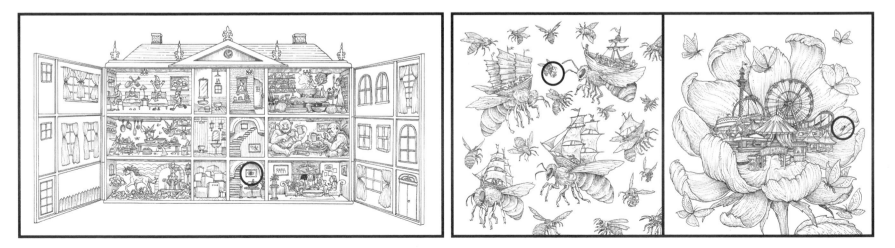

A bumblebee

A flower

An ant

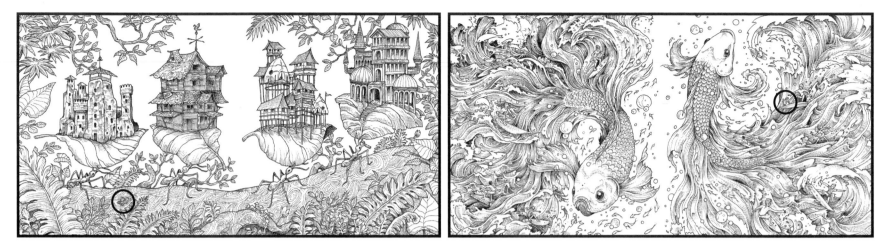

A fish

A rabbit

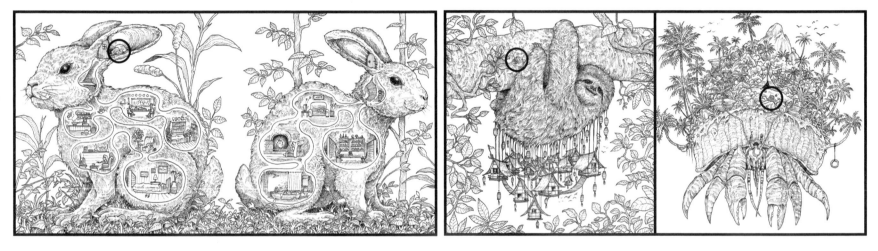

A sloth

A hermit crab

A lily pad

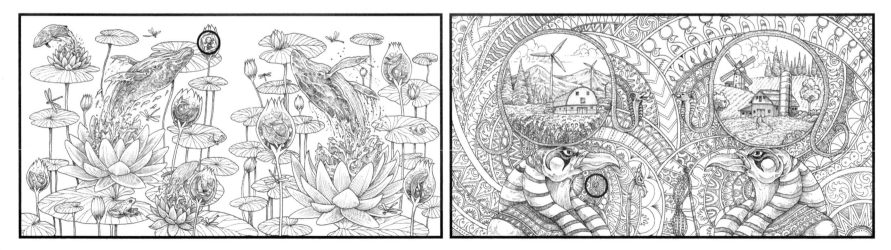

An Egyptian god

A snake